BE BAD,
BE BOLD,
BE BILLIE

BE BAD,
BE BOLD,
BE BILLIE

Live
Life the
Billie Eilish
Way

SCARLETT RUSSELL

HarperCollins*Publishers*

HarperCollins*Publishers*
1 London Bridge Street
London SE1 9GF

www.harpercollins.co.uk

First published by HarperCollins*Publishers* 2020

10 9 8 7 6 5 4 3 2 1

Scarlett Russell asserts the moral right to be identified as the author of this work
Illustrations by Amelia Deacon

A catalogue record of this book is available from the British Library

ISBN 978-0-00-840848-0

Printed and bound by PNB, Latvia

MIX
Paper from
responsible sources

FSC www.fsc.org **FSC™ C007454**

This book is produced from independently certified FSC™ paper to ensure responsible forest management.

For more information visit: www.harpercollins.co.uk/green

This work has not been officially endorsed by Billie Eilish, but pays homage to the multi-talented icon that she is. Written by a fan, for fans, it is a tribute to Billie and everybody she inspires.

Thank you, *BILLIE.*

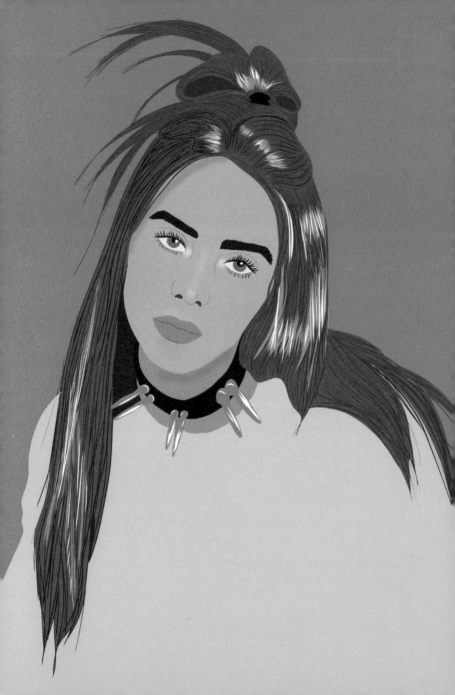

CONTENTS

INTRODUCTION: AN ODE TO BILLIE

In the spring of 2019, a pop star exploded onto the music scene, through the mainstream and straight into public consciousness. Seemingly out of nowhere (though she had been quietly making and releasing music since the age of 13), Billie Eilish Pirate Baird O'Connell, at only 17 years old, released her debut studio album, *When We All Fall Asleep, Where Do We Go?*. It was nothing short of a game-changing record – and she was nothing short of a pop phenomenon. Worshipped by fans, acclaimed by critics and embraced by the music and fashion worlds, Billie's music, attitude and image came to define the entire year. *Duh!*

The year before, female pop stars ruling the charts included Ariana Grande (who released *Sweetener*), Taylor Swift (with *reputation*), Camila Cabello (with her debut album, *Camila*) and Cardi B ('I Like It' was one of the biggest songs

of the year). Astonishingly successful 20-something singer-songwriters, they were all about power ballads, dazzling music videos and glamorous outfits. But when Billie burst onto the scene a few months later, releasing her breakout single, 'bury a friend' in January 2019, she gave us something *completely* different. Her deep, sultry vocals were so soft, they were barely a whisper. Her gothic-tinged music video was entirely black and white save for Billie's turquoise-dyed hair. Like something out of a horror movie, the video featured flashing lights and syringes being thrust into Billie's back as she sang about wanting to 'end me'. She was dressed in white baggy clothes and thick silver chains; less pop princess, more Eminem.

We were hooked.

When We All Fall Asleep, Where Do We Go? was released that March. By July, it had been streamed more than 2 billion times, sold over 1.3 million copies in the US and became the year's best-selling album in Canada. In the UK, it had made Eilish the youngest female solo act ever to reach number one in the charts. Billie churned out more hits ('bad guy', 'wish you were gay', 'all the good girls go to hell'). She was booked to play Glastonbury and Coachella – festivals that have hosted the biggest names in music, from Beyoncé to the Rolling Stones. She graced numerous magazine covers – from *Rolling Stone* to *Vogue* – and would go on to win five Grammy Awards in February 2020, for Best Song ('bad guy'), Album, Record, Pop Vocal Album and New Artist. That same month, it was announced she would record the theme song for *No Time to Die*, the new James Bond movie, becoming the youngest artist ever to do so. She had only just turned 18.

But what is it that has made Billie so successful and appealing? How has a teenager from Los Angeles, California,

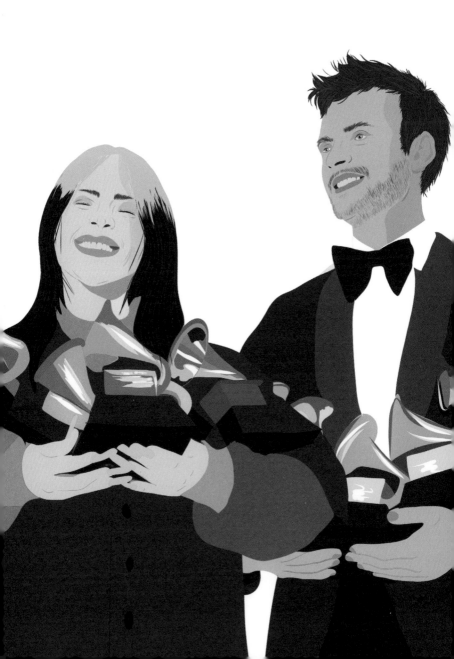

managed to command so much attention and fandom? Who is this girl, with her big sunglasses, grunge-green roots, black hair and big doey eyes beating the likes of Ariana Grande and Ed Sheeran on all the recent streaming charts?

For one, Billie's emo-image is the refreshing antithesis of bubblegum pop. On the cover of *Rolling Stone* magazine, she was praised for her 'triumph of the weird'. Her fashion sense remains over-sized, covered-up, big and bold. Where other starlets wear flowing dresses and high heels on the red carpet, Billie bears sneakers and custom-made Burberry coats and T-shirts. Her songs are infectiously catchy and unlike any other sound in the charts today. To her core audience, Billie speaks directly to us through her lyrics. She sings of angst, pain and boredom; parties, rejection and love. She's open and frank about her struggles with depression. She also talks openly about having synesthesia (the neurosensory wire-crossing in which different senses seem to blend together), as well as a form of Tourette syndrome (see also page 86), which means she involuntarily rolls her eyes.

Billie's a Belieber. Her best friend is her brother, Finneas, who co-created her hit album (it was, in fact, recorded in Finneas's own bedroom). She calls out grown-ups and politicians and does things on her own terms. She regularly advocates veganism to her millions of Instagram followers. She courts controversy with her contentious lyrics and bold statements (in a cover interview with *Vogue*, Billie sparked backlash when she said, 'There are tons of songs where people are just lying. There's a lot of that in rap right now.') She isn't afraid to speak her mind.

But most of all? People just love her. The actor Jared Leto (*My So-Called Life*, *Into the Wild*) asked Billie to perform her songs at a private party because he was such a

fan; Hollywood actor Leonardo DiCaprio watched from the sidelines as she performed during the iconic comedy show, *Saturday Night Live*. Her success, crowds and sell-out shows speak for themselves. But, to her fans, Billie manages to be both relatable and stratospherically famous, which is no mean feat.

This book is an ode to Billie; a celebration of a thoroughly modern pop star and a guide to how you, too, can learn from her. Each chapter will examine Billie's life, career, style, statements and music. Looking at Billie's words and actions, it will also provide you with the tools, tips and guidance to inspire you, make you feel even more badass than you already are, and it might even help you through a struggle or a difficult time in your life. It will also be a lot of fun! We'll delve deep into how Billie creates the songs we love, how she bosses her mental health struggles and has embraced the fine art of self-acceptance. We'll look at how she loves her family and fans and how, with her sass and business brain, she runs her empire, not neglecting the mistakes she's made along the way (hey, none of us are perfect, even Billie!). With activities, quizzes, tips and tricks that you can do anywhere, with anyone or by yourself, this book shines a light on what it means to be bad. To be bold. To be Billie. Enjoy!

'Around when
I turned 16,
I died, and I got
reincarnated as
Billie Eilish.'

BILLIE

MAKES IT HAPPEN

Anyone who wasn't familiar with Billie Eilish before her debut album, *When We All Fall Asleep, Where Do We Go?* was released in March 2019 may see her stratospheric success as rapid. In fact, her assent to world domination was a few years in the making. Sure, she's still only young, but her steely determination and ability to hone and own her talents and strengths is something that we can all learn from. Billie makes it happen – so how can you do the same?

Billie was born in the Highland Park area of Los Angeles on December 18th, 2001, miles away from the posh Beverly Hills and trendy West Hollywood, which is steeped in music legacy. Her parents, Maggie Baird and Patrick O'Connell, were musicians who had both worked as actors. Money was tight growing up, but it was a happy and loving environment forBillie and her brother Finneas, who is four years older than her. Maggie and Patrick 'home-schooled' their children, meaning instead of drawing lines on a blackboard and studying to a regimented curriculum, Billie and Finneas explored and discoveredwhatever they felt like that week, whether it was museums, galleries, art or science. It was a musical family where creativity was encouraged.

6 Music was always underlying. I always sang. It was like wearing underwear: it was just always underneath whatever else you were doing. 9

It was clear from early on that art, music and performing were important to both siblings. Finneas took a songwriting course with Maggie when he was 12 and then started writing and producing his own music. Before he and Billie found musical

fame, he appeared in hit TV shows *Modern Family* and *Glee*. From a young age, Billie would take pictures using her dad's camera and she loved to make up songs and dances. She wrote her first song aged four; 'It was about falling into a black hole, but being happy to be there,' she told *Coup de Main* magazine. By eight, she was singing in the local choir and taking dance classes, which she would continue for years. They were all ways of expressing herself.

BE BAD, BE BOLD, BE BILLIE

Dancing and singing are incredibly beneficial to our health and wellbeing and have been known to:

- ⟡ Increase coordination and muscle tone
- ⟡ Improve flexibility
- ⟡ Increase strength and vigour as training for the cardiovascular system
- ⟡ Reduce stress levels.

❝ I was just making songs with my brother. Now it's like a thing: I'm this artist. ❞

Perhaps part of the reason Billie is so talented, self-assured and confident is down to her ability to express herself in many different art forms. We might not all have as great a singing voice or be as good at dancing and songwriting as Billie, but that doesn't mean we're any less creative! Different people's creativity manifests itself in different ways – some might be great at performing arts while others are good writers or very

academic and express their creativity through language and science. But whatever tools you have to express yourself, use them! You have a voice and you have the right to use it in any way you like. (As long as you're not causing damage or hurting anyone, of course!)

The health benefits of singing are endless, too, and it really doesn't matter whether you can reach those high notes or not. After all, researchers at the University of Gothenburg, Sweden, found that choristers' heartbeats beat in unison when they sing together, bringing about a calming effect that is as beneficial as yoga. 'Song is a form of regular, controlled breathing,' said Dr Björn Vickhoff, who led the study. 'It helps you relax, and there are indications that it does provide a heart benefit.' And if you think choirs are exclusively for the church hall, think again! Singing groups have become trendy and more popular in recent years; in most cities there are all kinds of choirs, from those who focus on rock and pop to those exclusively for LGBTQ+ members. Whatever you're looking for, choirs and singing groups are a great way to meet new people. Have a browse around for singing groups in your local area.

If the thought of singing in front of anyone makes you want to crawl under your duvet, just think about all the other great hobbies and activities you could try instead.

BE BAD, BE BOLD, BE BILLIE

How do you like to express yourself? Are you passionate about anything in particular? Do you already have a few hobbies? If so, are you making time to do them?

- ✪ Write down things you love to do – anything from rock climbing, swimming, cooking, going to a yoga class, taking a trip to the cinema or reading.
- ✪ Make time to do each of your three hobbies over the next two weeks. Write down the activities in your diary, or pop them in your calendar and set a reminder. Already doing them? Try a brand-new hobby to shake things up!

In November 2015, when Billie was 13, she recorded 'ocean eyes', which was written and produced by Finneas. 'ocean eyes' is a dreamy pop ballad about being so in love with someone that it consumes you. Billie's delicate voice only adds to the haunting lyrics. It would end up becoming her debut single, but neither she nor Finneas ever imagined it would be so successful. In fact, it was intended for Billie's dance teacher, Fred Diaz, who wanted a song to choreograph a routine to. The siblings uploaded it onto the free music-

sharing website SoundCloud so that the teacher could access it, but it was listened to and shared so widely overnight that it racked up 1,000 hits. 'We thought that was a huge deal,' Billie told *Teen Vogue*. 'Which it was at the time, and it still is, but we thought it was because my popular friend reposted it. We didn't think it was anything besides that.'

It was only the beginning. A man called Danny Rukasin heard the song, contacted Billie and Finneas and offered to manage their careers. He is still their manager today. Radio stations all over started playing the track and by the following March, 'ocean eyes' had its own music video: one shot consisting of Billie behind a pink backdrop singing into camera. The streams, shares and views kept rolling in. By August, Billie had a record deal, and in November 2016 – exactly a year after she and Finneas first posted the song to the world – it was released as her debut single. Though 'ocean eyes' didn't top any international charts (number 38 in New Zealand and didn't quite reach the UK charts), that didn't matter to Billie. She never expected it to even get to that level and certainly didn't expect it to be the track that would change her life. By the summer of 2019, it had peaked at number 84 in the US charts, which was still a huge accomplishment. At the time of writing, 'ocean eyes' has had half a million Spotify streams and over 227 million YouTube hits.

By 16, Billie was showcasing her music at festivals such as South By Southwest (SXSW), a prestigious music festival in Austin, Texas. She also signed a contract to model with Next Models and was placed on the Forbes 30 Under 30: 2018 list. In 2017, Billie recorded the song 'bored' for the soundtrack to the popular Netflix series, *13 Reasons Why*. The fit couldn't have been more perfect. The series was about angst-ridden teenagers and centred around a very dark storyline which

21

Billie's haunting music complemented immeasurably. Her career essentially went from strength to strength. Her music spread, as did her fame, and she was touring across Europe and America by February 2018, over a year before *When We All Fall Asleep, Where Do We Go?* came out. All this time she was recording and releasing music. In January 2019, two months before she released her debut album, she released an EP called 'don't smile at me'. It reached 1 billion streams on Spotify, making Billie the youngest artist ever to top 1 billion streams on a project.

> ❛ **This thing that meant a lot to me can mean something to you; that's always what I thought was really cool.** ❜

Take a moment to appreciate your own accomplishments. You may not have given yourself enough credit for completing a tough project at work or college or overcoming a tricky challenge. We're so busy all the time that it's easy to take our achievements for granted, or even overlook them sometimes. But positive-thinking people know when they have accomplished something great. It's not about dwelling on it for hours (there's always another goal to set, after all!), but it's really important to understand your strengths and achievements and feel good about them. Try making a list of things you've accomplished in areas of your own life. Some examples might be graduating from college or university, passing a driving test, landing a job, doing well in an exam or volunteering for a charity or a good cause. How about you make a habit of doing this every few months to see how far you've progressed?

Now, Billie's accolades include five Grammy Awards, two American Music Awards, two Guinness World Records, three MTV Video Music Awards and one BRIT Award. She is the youngest person (and only the second person ever) to win the four main Grammy categories – Best New Artist, Record of the Year, Song of the Year and Album of the Year – in the same year. In 2019, *TIME* magazine placed her on their inaugural TIME 100 Next list.

Billie's success story is not for everyone – but we can still be inspired by her needs and desires to achieve greatness. How often do you set yourself goals of things that you want to achieve over the next few months – or even years? How often do you revisit your list? Setting goals is an important tool for progression in all areas of life. It helps us focus and triggers a helpful mindset. Everyone from sports stars to business leaders sets themselves goals and regularly revisits their list to check in on their progress. Goal-setting is a technique that lots of therapists recommend to their patients to help reshape and balance their lives. Anybody can benefit from taking the time to think about what they really want.

BE BAD, BE BOLD, BE BILLIE

✦ Write down five goals and a 'completion date' for when you want to achieve them by. These goals can be related to any part of your life, from finance to romance, career to friendships. If you're still in education, maybe you want to start a new society within the next month. If you're in the world of work, perhaps you want to get promoted

within six months or start a side-hustle in two? Maybe you have a more long-term goal of buying your own place within the next five years, or you might just want to save up to treat a friend?

- ♻ For each one, write down the reasons why achieving this goal is important to you, what you already have in place or what you know will help you to achieve that goal. Also consider the potential challenges and obstacles for each one. Your goals should be realistic but still fairly difficult.
- ♻ Now, make a plan. What are you going to do to ensure you meet your goals? How can you go outside of your comfort zone to achieve them? How much time each week can you realistically spend focusing on your goals?
- ♻ Be sure to make a note of your progress as you go. Good luck!

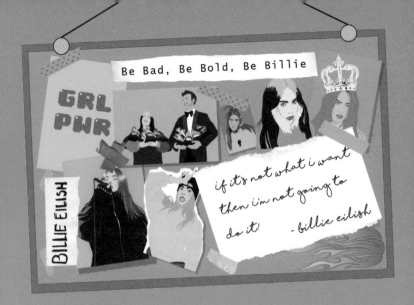

How to make a vision board

Sounds kooky, right? Don't be put off. Vision boards can be a very useful tool in achieving what you want. And the fun part? Your board can be whatever you want it to be. The purpose is to bring everything on it to life, so it should be made up of anything that inspires and motivates you. Simply buy a plastic or corkboard from a stationery store (you may have one lying around anyway!) and get going. Need some inspo?

- Set aside an hour or two to put your board together and set the speakers to Billie's music, naturally.
- Rifle through magazines and tear out anything relevant.
- Write down the most inspiring Billie quotes on scraps of paper.
- Print off photos of places you want to go, friends or anything else that inspires you.

- Lay everything out before you start gluing and pinning so you get an idea of where you want it all to go.
- Keep your board somewhere you look at regularly – the more you look at your board, the more you will be able to see your goals. Achieving them will become ingrained in your mind – this will help motivate you. Billie would be proud!

Billie credits much of her success to Finneas, who has a hand in every single record she puts out to the world. She dedicated the track 'everything i wanted' to him and regularly cites him as not only her brother, but her best friend and sole collaborator. She keeps it in the family in other ways too: both Billie's parents work on the road with her. Patrick figured out how to rig lighting for her early shows, while Maggie goes everywhere with her daughter and even helps pack her bags. 'The only reason I do what I do is because my parents didn't force me,' she told *ELLE* magazine. 'If they'd said, "Here's a guitar, here's a microphone, sing and write", I would have been like, "Goodbye! I'm gonna go do drugs."' Indeed, as much as Billie sings about drinking, partying and recreational drugs, the truth is she doesn't touch the stuff. Her song 'xanny' is all about how she just doesn't 'get' what people get out of doing drugs – to her, it seems like a waste of time. She's well-brought up and, as far as we know, very well-behaved, and a huge part of this is having a great team – and an amazing and supportive family – around her. Despite her success Billie still lives at home with her parents and pets (a rescue cat, Misha, and a rescue dog, Pepper). Finneas has bought his own house just four minutes away. They still make music in

their childhood bedrooms, shunning big fancy studios – for now, anyway.

Like Billie, every successful person needs a strong team around them, whether that's family, friends, fellow students, business partners or colleagues. We all need people we can trust. In fact, having friends and positive people around us that we can rely on has been scientifically proven to help extend life expectancy. A Harvard study stated that 'people who are more socially connected to family, friends, and community are happier, healthier, and live longer than people who are less well connected.' One of Billie's closest confidantes is Zoe Donahoe and the two have been besties since they were toddlers. Zoe watched Billie's first-ever gig, an open-mic night at a local wine bar, shortly after 'ocean eyes' gained traction. Now, Zoe still flies out occasionally to join Billie on tour to keep her company and keep her happy. The Harvard study went on to say that being in a secure relationship even helps people's memories stay sharper for longer. Looks like your BFF can do a lot more than just take the perfect Instagram picture of you two on a night out!

BE BAD, BE BOLD, BE BILLIE

- ☙ Are any of your friends having a difficult time and could use a supportive phone call or text from you? Maybe now's the time to do it.
- ☙ What about that friend you haven't caught up with in months but keep saying you're going to meet? Message them now to make a date – and stick to it.

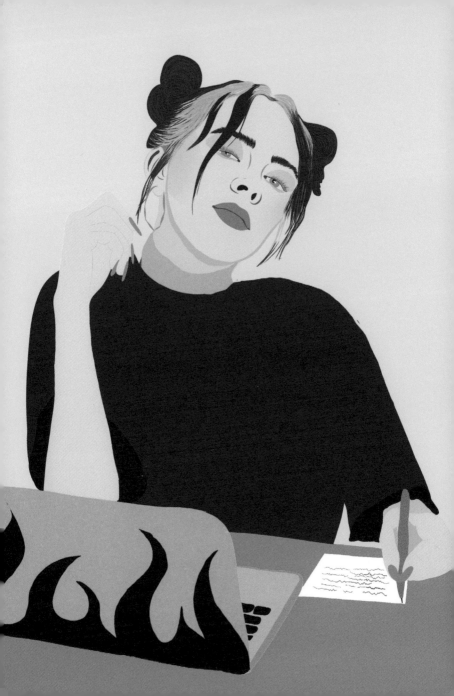

'I hope to show people that they shouldn't care what other people think of them. I am really weird and, you know what? I like it, it's special to me, and it's fun to be weird. It's you and it's your life. Do what you want.'

BILLIE

SAYS DO YOU

What makes Billie really stand out from the crowd is her individuality. Billie doesn't conform to a certain stereotype or play by the rules, she likes to break them. She likes to be unexpected. Unpredictable. The pop music industry's leaders have always been risqué. Madonna broke the rules, too, when she came to prominence in the 1980s, writhing around on stage singing 'Like A Virgin' in 1984. In 1992 she published a book, a heavy coffee-table tome, called *SEX*, which featured racy pictures of her and others (including model Naomi Campbell, actor Isabella Rossellini and rapper Vanilla Ice, to name a few) in highly compromising positions. It would raise eyebrows even today, but back then? Forget it! The book was *actually* banned. But breaking the rules is what made Madonna so unique – and her fans loved her for it. Now in her sixties, she's still touring and selling out venues worldwide. Guess she gets the last laugh! More recently, pop stars like Christina Aguilera, Britney Spears, Nicki Minaj, Lady Gaga and Miley Cyrus have all courted controversy just for being themselves, being proud of their own bodies, *owning* them and standing up for what they believe in.

> **❝ I'm gonna make what I want to make, and other people are gonna like what they're gonna like. It doesn't really matter. ❞**

Fortunately, we've come a long way and stars who express their individuality today are praised and admired instead of judged. Make no mistake, women are still under huge public scrutiny and are judged on their outfits and bodies far more than men are. But what's so wonderful about Billie is not just

her unique look, but her confidence to just be herself and be proud of it. 'I love girls who are comfortable in their skin, and they show their ass, they show their boobs and I support it so much. Because I see so many people ridiculing it, and it's so not fair,' Billie told the *Sunday Times Magazine*. 'I've always just known what I wanted. The only time it was different was when I was 11 and 12, when I tried to be like everyone else. I tried to fit in... it was the worst year ever. It made me miserable, and it also made me annoying because it wasn't authentic.'

Billie has certainly taught herself how to be authentic now. She knows that being yourself means you need to know yourself. But not everyone knows themselves as well as Billie, do they? In an interview with the website *Bustle*, psychotherapist and author of *Your Best Age Is Now*, Robi Ludwig, gave some great advice for boosting self-confidence: 'Work on the issues that are making you feel uncomfortable with yourself. Ask yourself, what you need to do or change to be a person who likes and respects themselves more. This can lead the way to discovering what you need to do to be more comfortable with who you are.'

❝I wasn't trying to break the rules. I wasn't doing something to make kids like me. I just literally did what I wanted. That's the only reason it worked.❞

According to the clinical psychologist Christina R. Hibbert, one of the keys to acing self-worth is to practise the following:

- Self-awareness: seeing ourselves exactly as we are, including our strengths and weaknesses.
- Self-acceptance: accepting all these parts of ourselves.
- Self-love: learning to appreciate ourselves as we are today and as we grow. This includes self-compassion, self-care and giving and receiving love.
- Self-worth: by practising the parts above, we start to feel our true worth. But remember, self-worth is a lifelong process.

BE BAD, BE BOLD, BE BILLIE

- Write down a list of all your strengths and weaknesses. Be honest, Billie certainly is. She writes down her thoughts and feelings – and makes those words into songs that millions of people around the world listen to and appreciate. Struggling to come up with your own list? Maybe ask your best friend to give you some guidance here. They know you well enough!
- Now, read out loud everything on your list. How are you feeling when you say each item aloud? Does it give you an idea of what you might want to work on? Uncovering weaknesses isn't easy, but how else can we grow?

♦ Self-love is more fun. It's all about doing things that make you feel good about yourself. Can you find time today to do at least one thing to make yourself feel good? Christina Hibbert splits self-love into five sections: Physical, Emotional, Mental and Intellectual, Social, and Spiritual. She suggests seeing what your needs are in each area and writing them down. Now, pick the top three needs you think will contribute to your optimal wellbeing, then choose one to work on today. And then keep working on the others as you go about your days.

6 I like being able to express myself with clothing. I don't mind being judged, so if someone doesn't like what I wear I am OK with it. 9

Around the time she landed her record deal with Interscope (a major record label), Billie's distinct look started to really take shape, and learning the important art of being able to express herself through clothes helped to form the image that she wanted to put out there. Gone went Billie's blonde hair, jeans and sneakers, replaced instead with chunky silver rings and chains, hair dye and clothes that you might have seen on a male hip hop artist from the 1990s rather than a glossy pop princess in the twenty-tens! It was all carefully curated to make Billie stand out from the crowd – and boy, did it work! But there was more to it than creating 'a brand'. By now, Billie was becoming more and more comfortable in her own skin and confident enough to have a hand in every decision, knowing what worked and didn't work for her. She told the *Sunday Times Magazine*: 'If I saw me I'd think, "Oh my God, she's dope. Like, look at her outfit, dude!" I think I would think I was so cool. But I would also think I was really annoying. I have always hated people who are like me. Whenever I meet someone with a similar personality to me, I think, "Eeww, shut up!" I just always wanted to be the only one doing me.'

The fashion world loves Billie and her distinct and unique style. She wore a custom-made Chanel outfit to the Oscars red carpet (where she and Finneas performed a stunning rendition of The Beatles' 'Yesterday' for the 'In Memoriam' song that evening). The outfit was made up of white baggy trousers and an oversized jacket emblazoned with the Chanel logo. The British fashion house Burberry have also designed outfits for Billie to wear on red carpets all over the world. Even Billie's nails are a strong part of her 'look'. Remember those signature long talons with the Burberry print that she sported for the BRIT Awards? Billie even sells her own 'Blohsh' merchandise, clothes and accessories through her website so we can all insert a bit more Billie into our wardrobes!

❝ I have always been a person that wants to dress loud. I always wanted to look loud, I've always wanted people to look up at me, I've always wanted people to notice me. ❞

Billie has spoken in more personal detail about why she prefers baggy clothes. In May 2019 she made a video for Calvin Klein in which she explained that she didn't want to be judged by her body, so she didn't want people to see her body, thus her love of baggy clothes. But she has also said that in future she might change her image entirely. Again, you never know quite what to expect with Billie! And, as we know, every female pop star worthy of a Grammy will master the art of reinvention. Think about how many different 'looks' Madonna and Taylor Swift have had! And their success speaks for itself.

Now, you may not love – or even care that much – about fashion. Maybe you've got better things to spend your money on than clothes. That's fair enough. But, for a lot of people, Billie included, fashion is a truly important tool in the art of self-expression. You don't need a big bank account or crazy style; it's about wearing whatever makes *you* feel good. Every day is an opportunity to embrace your individuality and reflect your personality through your style.

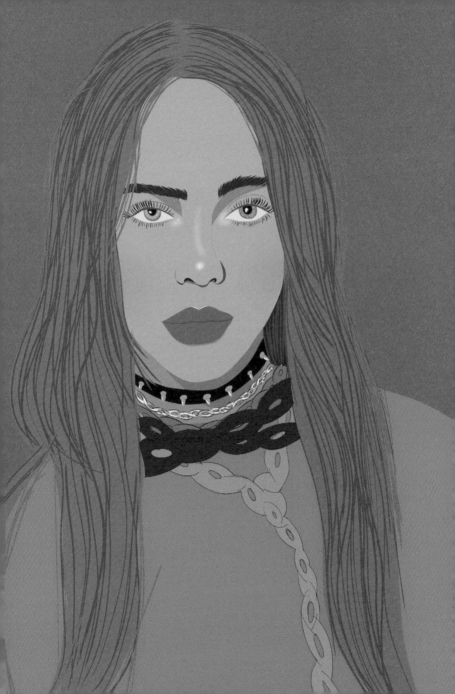

BE BAD, BE BOLD, BE BILLIE

- Dress how you want to, not how you think you should or to please anyone else. Ignore fashion trends if you don't like them. Think about the last outfit you wore that made you feel amazing!

- Rearrange your wardrobe, putting all the clothes you wear all the time to the front. Is there anything there that you never, ever wear? What did you used to love about it? If you think it's a bit 'out there', wear it anyway! Or, start a pile of unwanted clothes to take to charity shops and thrift stores.

- Pick three celebrities whose style you love and keep them in your mind next time you're shopping.

- Want to dress like Billie? An oversized hoodie paired with piles of chunky accessories is all you need! Charity shops and thrift stores are great places to experiment with different styles, plus you're helping the planet.

❝ I'm not going to say I'm cool, because I don't really feel that. I just don't care at all, and I guess that's what people think is cool. ❞

Learning to stop comparing yourself to others takes a long time to master. Feeling jealous or envious of others is only human, but it's important to hold onto those feelings and turn them into something positive. Let others inspire you to take risks and make new plans. Write down your thoughts

and feelings and aim to carve out the life you want with the powers you have. Celebrities including Jessica Simpson, Emma Watson and Lady Gaga are all mega-fans of this process, FYI! Writing things down can help you figure out what makes you truly content. Don't worry about what others would think or say if they saw your scribblings, just do you!

HOW TO 'DO YOU' THE BILLIE WAY:

- ✤ Know who your friends are and talk to them on the regular.
- ✤ Write down your feelings – good, bad, ugly, it doesn't matter. The simple act of penning thoughts and feelings is so powerful and you can keep referring back to this whenever you want to.
- ✤ Don't let anyone else try to define you – you're great the way you are!
- ✤ Be active. Whether it's dancing, running or just going on long walks, carving out time to look after your body and your mental wellbeing will reap the benefits as well.

'I was always the one in charge, the alpha. I've always wanted to be my own person – not controlling people, but controlling what I'm doing.'

BILLIE

MEANS BUSINESS

As we've seen, Billie is no stranger to success. From the age of 15 she was racking up platinum-certifications with her debut EP 'don't smile at me', multiple singles and her double-platinum debut album, *When We All Fall Asleep, Where Do We Go?*, which reached number one in 17 countries. But it's not just about selling records (though that certainly is a big part of it!). To be a cog in the gigantic wheel of the music industry, an artist needs to do much more than simply *make* music. When she's not recording with Finneas, Billie will be touring, planning a show or appearance, having meetings with her record label, talking to new designers who want to dress her, meeting fans, doing magazine or newspaper interviews, radio and TV spots, co-designing and signing her own merchandise or making a music video. She has even directed some of her music videos, including 'xanny' and 'everything i wanted'. She's had endorsement deals with Calvin Klein and Nike and is constantly thinking about what her next career move will be. She is effectively the CEO of her own brand and, as such, employs a raft of people, including managers to help oversee her career, publicists to manage press, chefs and personal trainers, security guards – and even her parents!

Billie really does have a hand in everything. In 2018, when she dropped the anthem, 'when the party's over', she came up with the concept for the accompanying video. In it, Billie, dressed all in white save for her heavy silver chains, chunky rings and blue hair, sits in a white room gazing at a glass of a thick black potion, eventually downing it in one, which causes her to cry thick, tar-like tears for a chilling yet beautifully hypnotic three minutes.

'I planned everything out like a director,' she told *NME* magazine. 'I went into my yard and told my mom to pretend to be me. I made her go outside with a table, glass and the chair in the position exactly where I wanted it and I started filming and deciding how we shot it and everything.'

❛I would rather not do anything at all than not be in control of it all. I can't not be involved, which literally drives me insane, because I don't have time to do it all. I'd rather have the career I have and have all the control.❜

Before she was signed to Interscope in 2016, Billie already had a loyal fanbase, thanks to the success of 'ocean eyes' the previous year. From being signed onwards, there were years of a carefully planned strategy – including song releases, touring and reinventing Billie's entire image and style – which led to her being the most talked-about teenager anywhere in 2018 to total pop-culture world domination in 2019 and beyond. But it did not happen by accident and involved a great deal of hard work, to which Billie is no stranger.

Think about your own work, school or college situation. Are you stuck at a crossroads where you don't quite know what it is you want to do with your life when you leave education? Perhaps you're in a steady job you're not hugely passionate about, but happy enough because it pays the bills while you live for the weekends? Maybe you want a successful and fulfilling career but aren't sure you're on the right path. All of this is fine. These times in your life are confusing and not everyone has all the answers. We aren't all

Billie Eilish

lucky enough to know exactly what it is that we want to do, unlike Billie, who had a strong idea of her own career goals from a young age. The good news is, wherever you are in your career, there is heaps of advice out there.

Ariana Dunne is a Dublin-based life and business coach and mentor who helps people of all ages further their careers and figure out what they might want to do if they're feeling in a rut. She talks about how 'What do you want to do?' are six words we hear all the time from parents, teachers and friends, but for the majority of people, it's one of the trickiest questions to answer. She goes on to describe how it's very common to fall into a job and get swept along without checking that it's what we really want to do. However, Dunne suggests that 'maybe it's the question, not the answer, that needs to be worked on. Maybe our parents, teachers and peers should ask, "What do you want to *be*?" instead. That should be an easier question to answer and within your response lies the clues to your life goals. When people I meet ask me what it is I do for a living my response is this: "I do what I am good at and passionate about, that helps other people and allows me to live the life I want to lead."'

Dunne outlines four key questions you need to ask yourself if you are not sure about what you want your career to be:

> 🡆 **What are you good at?** You can be good at a wide variety of things such as sports, cooking, offering advice, making people laugh, putting things in order, speaking in public or working well in a team.
> 🡆 **What are you passionate about?** What gets you excited? What evokes emotions such as anger, joy, love?
> 🡆 **What could you do that could help others?** Ultimately,

48

everything we do benefits others in some way. Doctors help sick people, actors entertain, mechanics fix cars so people can drive around. How will the job you want benefit other people?

🢂 **What kind of life do you want to lead?** Where do you want to live? How much money do you want to earn? What kind of things do you want to spend your money on? How can you best strike a good work/life balance? Are you happy with a 9 to 5 job that pays the bills, or are you set on a long-term career path that might involve flexible or unusual working hours?

Dunne adds: For someone who becomes a journalist, the responses could have looked like this:

🢂 I am good at writing, reading, being creative and asking questions.
🢂 I am passionate about telling stories, speaking to different people, uncovering the truth and sharing information.
🢂 This job would entertain, inform and educate other people.
🢂 I want to lead an exciting life meeting lots of different people, earning enough money to pay my bills and have enough left over to live a comfortable but not extravagant life.

49

BE BAD, BE BOLD, BE BILLIE

♦ Billie knows deep down that she likes to lead.
Try figuring out what you're good at. This might be
hard at first, but you can start online by taking the
Myers-Briggs test – a free 16-question personality
test which helps identify your character traits and
your strengths (so long as you answer honestly
and don't dwell on each question!).

**❝ I remember the first time I had any sort of
meeting with a label or management, I was 13.
I think the only people that didn't look at me like
I was going to have a horrible career were the
people that I ended up working with.❞**

As we have seen, Billie surrounds herself with a team of strong
people, and the record label executives are no different. 'I am
lucky and grateful that I have had the experience that I had
with my label and with my team and everyone, because I never
had any issues with people trying to pull me in a different
direction, one in which I would not want to be headed,' she
told *V Magazine*.

Her managers, Danny Rukasin and Brandon Goodman,
have been intrinsic to Billie's success as an artist. It was
Finneas who first reached out to Danny, via email, in 2016

about working with a producer friend of Danny's. At the time Finneas had his own 'garage pop band' and Danny loved his music, but it was when he sent some music that he'd been working on with his kid sister that Danny really sat up and took notice.

'"ocean eyes" drove all of us to take notice,' said Danny in an interview with *Music Business Worldwide*. 'The next day I was with [Finneas] and his family with Billie, meeting everybody, talking about what they wanted to do. The song had already crossed into viral territory overnight. We discussed whether or not this was something Billie was really interested in doing or just a hobby, and we got to know and understand Billie. It was still early stages, but she had a vision of how she wanted what she was doing to be put out in the world.'

Every successful person has a great team around them. Think of your boss, teacher or someone in authority that you really admire. They don't do it alone, do they? A good manager will always value their team. It's important to remember that having a mentor or peer you can talk to and go to for advice in your career will help you, no matter what stage you are at.

❛ Finneas is the only reason I'm anywhere in the whole world. He's probably the only reason I'm alive. ❜

There were tensions too, though. Billie told *Rolling Stone* magazine that when she first signed her record deal, she was encouraged by executives at the label to collaborate with older and more experienced songwriters. 'I hated it so much,' she said. 'It was always these 50-year-old men who'd written

these "big hit songs!" and then they're horrible at it. I'm like, "You did this a hundred years ago. Ugh." No one listened to me, because I was 14 and a girl. And we made "ocean eyes" without anyone involved – so why are we doing this?'

Learning to deal with difficult people in authority is something every single one of us will face at some point. It is inevitable. We are all different and many of us have different working styles and attitudes. This does not make you a bad person. Most of the time, it's just about trying to find a way that we can all work together in harmony and be kind and respectful as well as kickass at whatever it is we're doing! Unfortunately, whether you're at school, college or work, you will always run into people who can be rude, unhelpful, aggressive and even go so far as to bully others. Corinne Mills, author of the bestselling book *You're Hired! How to Write a Brilliant CV*, suggests some tips for dealing with difficult people in the world of work:

Be patient
Rather than reacting straightaway to somebody's negative attitude, consider what else they might have going on in their lives and maybe ask them how they are instead.

Be helpful
Perhaps you should try being honest, constructive and clear about what the issue is and what you really need from them to move forward.

'I HAVE ALWAYS BEEN THE KIND OF PERSON THAT KNOWS WHAT I WANT, AND IF IT'S NOT WHAT I WANT, THEN I AM NOT GOING TO DO IT.'

Be assertive

If somebody is making you uncomfortable by being aggressive, it's perfectly OK to walk away or let them know you're going to put the phone down and you will pick up the conversation again when they have calmed down.

Taking it higher should be a last resort

When you feel as though you've tried everything to resolve a problem, but there still appears to be an issue with a particular individual, then it's time to reassess the situation. Avoidance isn't ideal (or always possible), but you could try and deal with them as little as possible while ensuring your proportion of the work is always on point. You could reach out to other (trusted) colleagues for advice, or you might escalate the situation to somebody more senior. Mills says: 'You could consider raising a grievance or formal complaint about them but these rarely end in dismissal so you may still find yourself working with them – and yes, they are going to be very angry with you.'

Being assertive doesn't mean being aggressive. Assertiveness is having the confidence to say how you are feeling in a constructive way rather than leading by anger or frustration. We should always strive to be respectful of people around us (whether we secretly respect their opinions or not!) but being

truly assertive means boosting your self-esteem. When you have higher self-esteem and greater self-worth the opinions of other people really don't matter as much.

BE BAD, BE BOLD, BE BILLIE

- ✤ Write down 20 things you like about yourself. Are you a kind and supportive friend? Did you get some positive feedback on the last piece of work you finished? Are you a good writer or particularly skilled at illustrating? Did you send a care package or card to someone who didn't ask for it but really needed it? Are you brilliant at coming up with fun things for you and your friends to do?
- ✤ Write down 10 compliments you've ever been given. Think of all the nice things your friends, family or boss have ever told you – this could even be a compliment on your outfit from a stranger on the train that made you smile.
- ✤ Write down five work or school situations you've aced, projects you've been proud of or big things you have achieved.
- ✤ Tear each of the 35 positive facts into individual strips of paper and place them in a small jar. This is your 'Positivity Jar'. Every time you feel insecure or doubt yourself, pull something out of this jar to remind yourself just how awesome you are!

Mean business the Billie way:

Write down a problem that you are currently facing or experiencing at college, work or in your career in general.

⤷ Think of as many solutions as you can – even if some solutions are extreme and things you would never actually do, like 'resign tomorrow' or 'abandon my course'.

⤷ For each of these solutions write down the advantages and disadvantages.

You'll see there are some really helpful solutions and some really unhelpful ones too. The helpful ones are solutions that you can act upon. Not only is this a calming exercise, but it helps you distinguish all the solutions you have at your disposal to tackle whatever dilemma you are facing.

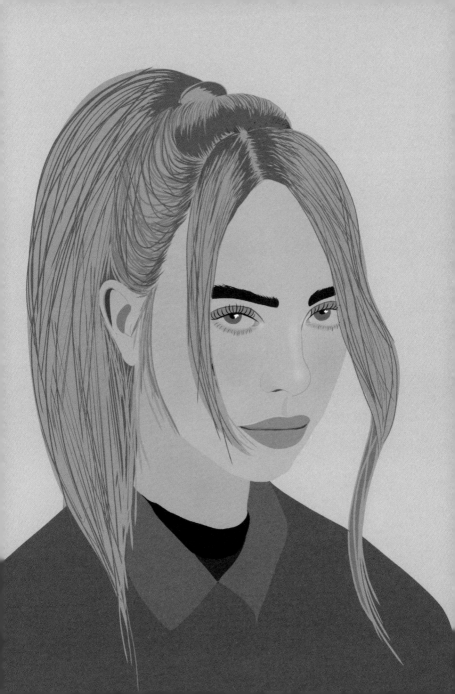

'I think it's
my best quality
and my worst quality,
how strong-willed I am,
because it has brought
me here. It literally
has created who
I am.'

BILLIE

KNOWS HER STRENGTHS

We know that the way Billie dresses is the complete antithesis to what many other successful, glossy pop starlets look like. She has made a point of hiding her body to encourage people to focus on her music instead – she followed her gut here and it paid off. Fans love her for it. Her strength and independence are incredibly inspiring. This no-nonsense attitude to her image is one of the things that makes Billie bad and bold, but how else does she draw on her strengths to achieve success?

Billie harnesses social media

After her incredible five Grammy wins in early 2020, Billie gave an interview on *BBC Breakfast*, where she admitted to backing off from social media. 'Two days ago, I stopped reading comments, fully,' she said. 'Because they were ruining my life. The cooler the things are that you get to do, the more people hate you. It's crazy. It's insane that I've been reading comments up until this point. I should have stopped long ago.' Billie knows that social media is a great tool for connecting to the fans that love her and don't want to bring her down, but she also understands the importance of having a healthy relationship with social media.

Chances are social media plays a huge part in your everyday life. The average person checks their phone 28 times a day, though for most Gen Z-ers it's more like 48! Billie has millions of followers on Instagram, where she posts all sorts of cool pictures, video snippets and even the odd sentimental or confessional message, like when she posted

a picture of her and Alicia Keys singing together with a heartfelt caption, or when she called the rapper Tyler, The Creator (one of her idols), a 'god'. But, like many of us, she has a complex relationship with social media.

❛I wish I could go back to the beginning and not show the internet who I am.❜

According to the Child Mind Institute in the United States, evidence is mounting that there is a link between social media and depression. In several studies, teenage and young adult users who spend the most time on Instagram, Facebook and other platforms were shown to have a substantially (from 13 to 66 per cent) higher rate of reported depression than those who spend the least time. A study conducted by the University of Copenhagen found that many people suffer 'Facebook envy', with those who abstained from using the popular site reporting that they felt more satisfied with their lives. In March 2018, it was reported more than a third of Gen Z, from a survey of 1,000 individuals, stated they were actually *quitting* social media for good as 41 per cent believed social media platforms make them feel anxious, sad or depressed.

In her book, *The Anxiety Solution*, clinical hypnotherapist Chloe Brotheridge breaks down the best way to 'cleanse' from social media and suggests doing so whenever you feel that, like Billie, your phone is affecting you in a negative way:

- Enforce a 'no email zone' between 9 p.m. and 9 a.m. – or choose hours to suit your life.
- Figure out what your triggers are – and block or unfollow them.
- Have an SOS (Switch-off Sunday), where you unplug your phone for the whole day.

Billie's Twitter account is still active, but she doesn't actually post herself. If you take a look, you'll notice that the posts are about her upcoming shows and accolades, where to buy tickets and find out more information rather than personal messages. Instagram is the platform she uses to speak to her followers, to share her life, to show her true self and, at times, even interact directly with fans. She's all too aware of the dangerous pitfalls of becoming obsessed with social media, but she also knows that it's hugely important to stay connected to her fans. Plus, it *can* be a lot of fun and be a positive space, too.

Twitter allows for quick-fire communication (isn't one of the best parts of watching TV shows not simply watching the show, but reading the hilarious posts when it starts trending?). On a more serious note, social media helps build relationships, fosters empathy and makes us more engaged with what's going on in the world around us. British activist Gabby Edlin started her charity, Bloody Good Period, in order to raise awareness of impoverished schoolgirls, female refugees and asylum seekers who can't afford to buy their own sanitary products. She garnered huge support through social media; her Instagram account now has over

'EVERYTHING COULD BE EASIER IF I WANTED IT TO. BUT I'M NOT THAT KIND OF PERSON AND I'M NOT THAT KIND OF ARTIST. AND I'D RATHER DIE THAN BE THAT KIND OF ARTIST.'

38,000 followers and she uses her page as a powerful tool to promote the cause and chart its success. In the States, Charles Kaolin, who was bullied at school, founded a start-up called The Unity Challenge, which uses social media as a way to encourage people to stop bullying.

Billie has learnt how to have a healthy relationship with social media, and so can you.

BE BAD, BE BOLD, BE BILLIE

- ✦ Next time you're tempted to check social media, write down a song lyric of Billie's that means something to you. What does that message tell you? Is there more you can gain by thinking about that, rather than endless scrolling?
- ✦ Another idea is to message a friend you haven't spoken to in a while, or reply to that text from a family member, instead of checking your Instagram feed.
- ✦ Pick a day this week not to look on any social media sites. You can still have your phone on and use it to call, text and email. At the end of the day, write down all the ways – negative and positive – that you felt different from abstaining for 24 hours.

Billie speaks to her fans

Forget all the 'internet trolls', as she calls them, Billie knows who her fans are and she loves them. It helps that Billie is young. Who better to speak to (or sing to) teenagers and young adults than a young adult herself, who is on the cusp of leaving her teenage years behind? 'I don't like to call them fans. They're my family,' she told *Vanity Fair* when she was just starting out. Billie understands exactly what her audience wants and how they will consume her music, lyrics and brand as a whole. The traditional success story for an artist was to explode onto the scene with one mega-hit that would pave the way for a hit album and subsequent singles. It's not enough now just to bring out an album and rely on their sales (seriously, do you even own a CD?). Before Billie had even brought out her first album, she'd hit 1 billion streams

on Spotify, 15 million followers on Instagram and increasingly sold-out tours. And she returns the kindness that her fans have shown her. Billie does 'meet-and-greets' on tour, where she interacts and hugs fans. She even surprised one of her British fans on Capital Radio, a 16-year-old girl called Marissa. Billie snuck up behind Marissa, causing her to burst into tears at the shock of meeting her idol. Billie knows she wouldn't be where she is without her supporters and wants to connect with them whenever she can.

What's perhaps even more telling about Billie's appeal is that it isn't just young fans who look up to her. Billie has garnered the respect of seasoned musicians who praise her individuality – and that is one seriously tough crowd! Dave Grohl, the drummer from Nirvana and frontman of Foo Fighters, took part in a conversation with Live Nation Entertainment CEO Michael Rapino at the Pollstar Live conference in February 2019 and said of Billie: 'The same thing is happening with her that happened with Nirvana in 1991... rock 'n' roll is not even close to being dead.' Billie's tour manager Brian Marquis told *Rolling Stone* that Thom Yorke of Radiohead said to him, 'I like Billie Eilish. She's doing her own thing. Nobody's telling her what to do.'

Let's not forget that Nirvana and Radiohead are considered two of the greatest bands of all time, so this is high praise indeed! And the list doesn't stop there. As we talked about earlier, Billie performed for Jared Leto and 'a bunch of his friends' – including Leonardo DiCaprio(!) – and they even shared a stage at the Music Midtown Festival in Atlanta. Spice Girl Melanie 'Mel C' Chisholm, Hollywood actress Julia Roberts and singer-songwriter Avril Lavigne are also huge fans of Billie, all having been spotted attending her shows. However, perhaps her biggest, most famous

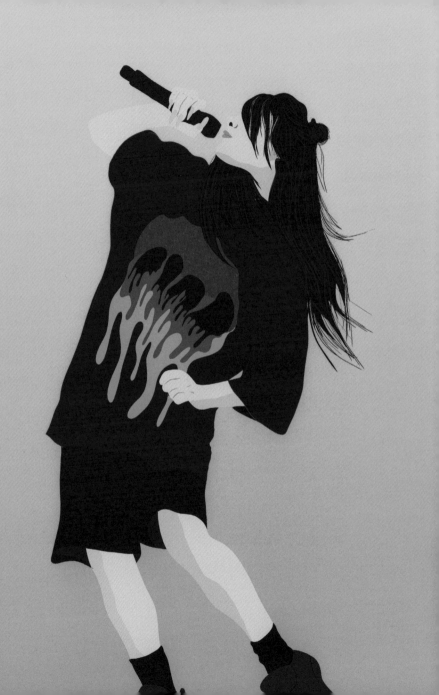

fan is the one and only Justin Bieber. The two *finally* met at Coachella festival in 2019, after Billie's iconic gig, which Justin watched from the sidelines in awe. The moment they met and embraced was filmed by fans and instantly went viral. Bieber even got teary-eyed when talking about Billie in an interview with Apple Music's Zane Lowe in support of his album, *Changes*: 'I just want to protect her, you know? I don't want her to lose it, I don't want her to go through anything I went through. I don't wish that upon anybody. So, if she ever needs me, I'm just a call away,' he said. And rapper Stormzy couldn't help but grab a hug with Billie on the red carpet at the BRIT Awards, gushing over her songwriting abilities. Is there anyone who isn't #obsessed with Billie right now?

BE BAD, BE BOLD, BE BILLIE

Make a point of making three people feel good this week. Write an encouraging comment under someone's Instagram post, praise a colleague or fellow student for a piece of work they did or send a supportive message to a friend or relative. Don't these random acts of kindness feel great?

Billie has autonomy

John Janick, chief executive of Interscope, recalls of Eilish: 'Her sense of style, how she thinks, the way she talks – everything about her was just different. She had such a strong point of view, especially for being 14 years old.' Billie insists on controlling – or at least having a heavy hand in – every aspect of her career. 'I could easily just be like, you know what, you're going to pick out my clothes, someone else will come up with my video treatments, someone else will direct them and I won't have anything to do with them,' she told *The New York Times*. 'Someone else write my music, someone else produce it, and I won't say anything about it. Someone else run my Instagram.' But then she wouldn't be authentic, she wouldn't be the Billie we know and love.

To date, Billie has directed five of her music videos, something she always wanted to do. Initially, she did so against the will of outsiders – presumably record executives or label managers who thought she was too young to try. 'There's this weird world of "You don't have any experience so you can't have the job." It's like, well, how am I supposed to get the job if I can't get any experience? I think that's a big problem in the world with women. I don't think people like us being the boss. They really didn't want a 14-year-old girl to direct a music video,' she told the *Guardian*. She did so anyway for her song 'xanny' – and sure enough proved them wrong!

6In the public eye, girls and women with strong perspectives are hated. If you're a girl with an opinion, people just hate you. There are still people who are afraid of successful women, and that's so lame.9

Billie has her family around

We know how close Billie is to her family and how supportive her parents, Maggie and Patrick, are. Though heavily involved, they have never forced Billie into the music industry, unlike some pushy stage mothers and fathers. The bond with Finneas goes even deeper. He doesn't steal any of Billie's limelight, nor does she hog the limelight for herself. When she comes on stage at the start of every gig, with Finneas leading the band, she always thanks him – 'my brother and my best friend'.

Some of Billie's most famous songs have been co-written by her and other songwriters and still produced by Finneas. And some songs that Billie and Finneas wrote have been produced by others. But they are not the songs Billie likes best and, to her, nothing feels better than making music solely with her brother. She followed her gut and knows what works. And the results speak for themselves!

BE BAD, BE BOLD, BE BILLIE

- Your gut knows: listen to it.
- Write down three occasions when you have followed your gut instinct and it paid off.

 - Did you get a bad feeling about a potential love interest and swerve them just in time?
 - Did you take a chance on a subject or degree you didn't have much knowledge of because your gut was telling you you'd love it?

What other times in your life have you followed your gut instinct? Perhaps ask a trusted friend or relative if you aren't sure.

- Next time you have a tough decision to make, use the space below to try to work out what your gut is trying to tell you.

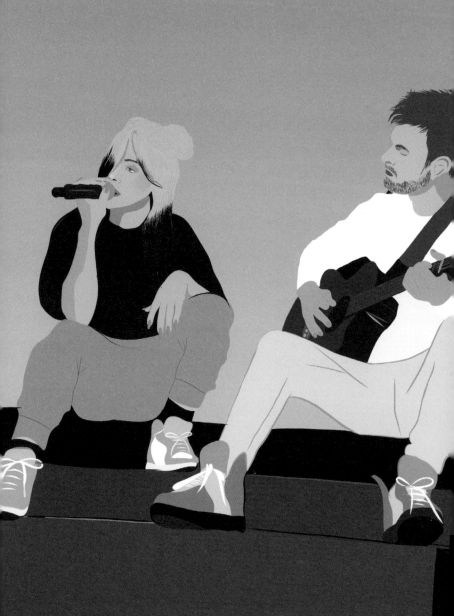

❛ Maybe people see me as a rule-breaker because they themselves feel like they have to follow rules, and here I am not doing it.❜

Billie doesn't hold back, as you can tell! But you can imagine how hard it must have been when she was starting out to try and find her voice – particularly when in a room full of older people who all thought they knew better. So, what can we learn from Billie about not holding back and finding our own voice and strength as she does? In their book, *How Women Rise*, Sally Helgesen and Marshall Goldsmith identify 12 habits that can hold many of us back in all areas of our lives, preventing greatness we could all achieve. These are just a few of the bad habits that they believe are holding women back. Do any of them sound familiar to you?

- ✪ Reluctance to claim your achievements
- ✪ The desire to please everyone else
- ✪ Worrying and obsessing about things you can't control (we call this ruminating)
- ✪ Striving for perfection
- ✪ Trying to do too much.

Helgesen and Goldsmith explore how events in our pasts may well shape our behaviour, but they suggest that these events don't have to 'determine' how we behave forevermore. We have the strength and power to improve our reactions, to become more 'present, assertive, autonomous, more at ease exercising authority and a more effective advocate' of ourselves. However, we can't start making these improvements before we have identified the habits that

hold us back and 'start making new habits that better serve us'. Wise words!

Do you think Billie obsesses over things that she cannot control? Does she strive to please everyone around her? Of course not! Billie is the most authentic version of herself.

Dr Ilene Strauss Cohen wrote an article for *Psychology Today* in which she describes striving for perfection as 'That feeling you get when you expect things of yourself that you'd never expect from others. It's working yourself to exhaustion in hopes that you'll feel whole, complete, worthy. It's basing your self-worth on external accomplishments, feeling like you have something to prove all the time. It's piling on the emotions of guilt, burnout, and self-hate. It's always coloring inside the lines and giving yourself the metaphorical whip if you screw up.'

Strauss Cohen goes on to say that perfectionism thrives in your fear of making mistakes, and when you're afraid of what might happen, you don't make the best choices. You end up limiting your options because you don't think you'll be able to cope with a negative outcome. She says, 'Allowing perfectionism to run the show is like being on a hamster wheel; you just keep going and going and going, even after you've reached your original goal. You increase the stakes every time so that when you do accomplish something, you wonder if you could have done it better.' Thinking in this way is no surprise when we are inundated with external pressures to be perfect, she adds.

BE BAD, BE BOLD, BE BILLIE

✣ Let go of the need to be perfect and accept who you are: you are enough.

✣ In the space below, write down what values are important to you and where you want to expend your energy. Refer to this list the next time you feel the pressure to be perfect – or do more than you are capable of.

✣ Adopting not only a 'to-do' list but a 'done' list can make a person 23 per cent more productive, according to psychologists at Harvard University. Just seeing a list of your achievements is so motivating. Give it a go!

Billie knows when to ask for help

We can see how Billie harnessed her inner strengths to get to where she is today, but it's also important to remember that her journey was not without its struggles. And, like all of us, Billie will experience more struggles throughout her life. There are things we simply cannot control (as much as we would like to) and this is nothing to be scared or ashamed of. What makes people strong is their ability to ask for help when they need it, instead of suffering in silence.

In January 2020 Billie revealed that she struggled with her mental health in the early stages of teen-hood. 'I was so joyless,' she told the American news channel CBS. Billie credits her mother for helping her pull through. Maggie made the necessary changes to Billie's gruelling tour schedule and encouraged her to go to therapy.

We all experience dark times and we can feel that we have no one to turn to. It's important to remember there are people who will always want to lend an ear, or be a shoulder to cry on. Maybe you know somebody who is feeling low and you aren't sure how to help them. Try encouraging them to open up to you or to talk to a friend or relative. However, if this isn't an option, let them know there are charities and groups who are there to help. There are 24-hour phone lines – we've listed some useful websites at the end of this chapter. Sometimes people actually find it easier to talk to someone they *don't* know!

BE BAD, BE BOLD, BE BILLIE

- ✦ Be OK with saying 'I'm not OK', if that's how you are feeling. Know that there are websites you can visit and helplines you can phone if you truly feel that none of your friends and family will understand.
- ✦ Don't be afraid to tell someone that you're not coping very well right now. We all feel this from time to time.
- ✦ Ignore the stigma that comes with mental health. If Billie can be open to millions of people around the world about her struggles, you can too!
- ✦ If someone you know is feeling down, ask them what you can do to help. Try to schedule some outdoor activities or exercise. Let them know that you are there for them. Suggest healthy and fun things that you can do together, like a movie night or cooking a delicious dinner. If you are seriously concerned, know that you can reach out to one of the groups in the resources section for additional support and guidance. There are also heaps of useful tips on these websites about mental health and how to support someone you care about who is struggling. It's important to be patient, kind and caring, just as Billie would be.

'When
people ask
me what I'd say to
somebody looking for
advice on mental health,
the only thing I can say is
patience. I had patience
with myself. I didn't take
that last step. I waited.
Things fade.'

BILLIE'S

LESSONS IN

SELF-ACCEPTANCE

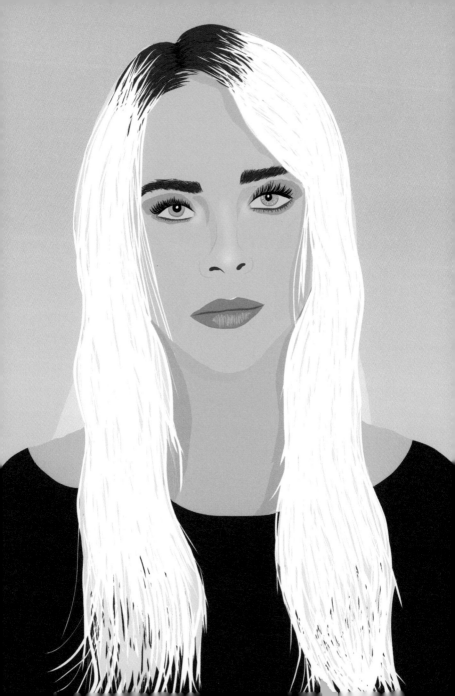

As we have seen, Billie has been open about her struggles with depression and she's not alone in having worrying and negative thoughts. Twenty per cent of adolescents may experience a mental health problem in any given year. In 2019, an NHS survey of young people in England, selected from GP records, found a rise in disorders like depression and anxiety, especially among girls. Billie has said that during a tour of her music in Europe in 2019, she experienced her 'lowest point', telling *Vogue*, 'I was worried I was going to have a breakdown and shave my head'. This is very telling. By this point Billie was on the cusp of super-stardom and worldwide fame, although she already had millions of adoring fans and a career most singers and aspiring pop stars only dream of. Things were gearing up for her in a big way and, when it all came to her, she struggled emotionally. She also alluded to some of those feelings in the song 'everything i wanted'. So what does this tell us about fame and fortune? Could it be that it's not all it's cracked up to be?

❛ Everybody has felt sad in their lives and of course it's really important to promote happiness and loving yourself – but a lot of people don't love themselves.❜

Billie's struggles with self-love and self-acceptance started from a young age. She became immersed in contemporary dance and, aged eight, joined the Los Angeles Children's Chorus. Over the years she built on her dancing – everything from ballet and jazz to hip hop and tap. When she was 12 she joined a competitive dance company, where she said

that she was surrounded by 'really pretty girls. That was probably when I was the most insecure.' She has also said that everything up until age nine was great and after that she started becoming aware of – and feeling bad about – what she looked like. At the dance company her confidence took a nosedive and this affected her wellbeing. She started to really look at herself and felt even more self-conscious about her body. This will be familiar to many 13-year-olds, but surrounded by a group of girls she didn't feel that she was part of, having to wear revealing outfits which she has called 'really tiny' among the competitive world of performing arts, must have been particularly tough for young Billie. She has revealed that she developed body dysmorphia at this time, which is where you have extremely negative views of what you look like. Though she later sought therapy, these issues never really go away fully and so you can understand why she might feel more comfortable in loose-fitting, baggy clothes that don't reveal her body.

It's not that Billie is ashamed of her body, she just doesn't want her body to define her. She wants people to focus on her music and the messages of her lyrics rather than the way she looks. While she understands how fashion can be fun and playful, and she enjoys that aspect of her image very much, what someone looks like underneath their clothes should never be a focus. Don't you just love Billie even more now?

Sadly, things got even worse for Billie. She was in a hip hop class with 'all the seniors, the most advanced level,' she told *Rolling Stone*. One day, she ruptured the growth plate in her hip and had to quit dancing altogether. 'I think that's when the depression started,' she added. 'It sent me down a hole.' Billie explained that around the age of 13, every time she was alone, she 'would break down and kind of crumble... It got to

the point where my friend would say, "I'm going home, see you", and I'd get this feeling in my stomach like a knife being twisted around.'

❝ I feel like I try to stay away from that side of my brain, thinking about how I am. I feel like if I do, I get inside my head and wallow into a pit of sadness. ❞

Billie has overcome so much already. She has found comfort in her friends, her family and her art, which has helped her to move forward. It's important to work out what makes you feel better when you're feeling low. There will *always* be something, or someone, that makes you smile, or lifts your spirits.

If you practise yoga, you'll be familiar with the repeated use of 'mantras'; originally from the Hindu and Buddhist religions, they are defined as a word or sound repeated to aid concentration in meditation. In everyday life, it means to repeat a statement or slogan frequently, and you don't need to have attended a yoga class to benefit. In these modern times, the stigma associated with mantras, which are seen as 'kooky' or 'woo woo', has been lifted. Scientific research has found evidence that mantra meditation can improve mental health and psychologists have suggested using morning mantras as just one thing you can do to help alleviate negative thoughts. Repeating mantras in the morning sets a tone for how you'll view and respond to situations throughout your day. Mantras set a positive intention for where your focus and energy should be and are also a great tool for your meditation practice. Give them a try!

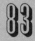

BE BAD, BE BOLD, BE BILLIE

- ✦ Sit in a quiet and dimly lit room, perhaps light a candle and set a two-minute timer on your phone.
- ✦ With your eyes closed, slowly and deeply breathe in and out, repeating the mantras in your head or even say out loud: 'I am powerful', 'I am enough', 'I love'.

You know that saying, 'every cloud has a silver lining?' Well, this is what happened to Billie. Her music career started taking off around the time of her injury, so it would be some years before she sought therapy. It's an example of how the rough comes with the smooth. But it's also important to remember that while feelings of depression may come and go in waves, typically those feelings will seem much more significant when something goes wrong in your life and far more manageable when good things happen. But, unless you seek help and change your negative thought patterns, the good moments in your life will only mask the negative thoughts and feelings temporarily; they won't be banished completely. In her book, *13 Things Mentally Strong Parents Don't Do*, psychotherapist Amy Morin draws on a simple but effective technique that can help reframe your bad thoughts. It was developed by PracticeWise, an American group that works with doctors on children's mental health issues. But Morin found that this technique can easily apply to adults as well. It's about turning BLUE (or, negative) thoughts into helpful ones. BLUE is an acronym that stands for **b**laming myself, **l**ooking for the bad news, **u**nhappy guessing and **e**xaggeratedly negative.

Here's how to spot BLUE thoughts:

- **Blaming myself.** While it's important to take responsibility, excessive self-blame isn't productive. In fact, it's been linked to mental health problems like depression. So be on the lookout for times when you tell yourself that you've 'ruined everything', or that something is 'all your fault'.
- **Looking for the bad news.** If lots of good things and just one bad thing happen in a day, it's easy to focus on the one bad part, right? But dwelling on that will keep you stuck in a dark place. Try to step back and create a more balanced, realistic outlook.
- **Unhappy guessing.** Even though you have no idea what will happen tomorrow, you might predict doom and gloom. Whether you imagine that you're going to embarrass yourself at a party, or tell yourself that you'll never get that promotion or fail that exam, unhappy guessing can turn into a self-fulfilling prophecy if you're not careful.
- **Exaggeratedly negative.** Telling yourself that the entire interview was a complete disaster or convincing yourself that everything about your job or course is terrible leads to a downward spiral. The more negatively you think, the worse you'll feel. And the worse you feel, the less likely you are to take positive action.

BE BAD, BE BOLD, BE BILLIE

- ✥ Once you identify a BLUE thought, try to replace it with a true thought. One of the best ways to do this is to ask yourself, 'What would I say to a friend who had this problem?'
- ✥ Write down what possible evidence there is for you to assume the worst. Is this type of negative thinking actually based on fact or just your paranoia? Don't be so hard on yourself!
- ✥ When you find yourself focusing on negative things, start thinking about ways to do better next time. You can always learn from mistakes; that's what they are there for.
- ✥ Stick on some of Billie's tunes that you like best and remember, Billie doesn't let her struggles define her and neither will you!

❝ It doesn't make you weak to ask for help. It doesn't make you weak to ask for a friend, to go to a therapist. It shouldn't make you feel weak to ask anyone for help.❞

Billie's problems haven't just been depression. In November 2017, she wrote a very revealing and personal post on her Instagram feed. She told the world that she suffered from Tourette's syndrome, a neurological disorder that causes a

person to have involuntary physical or verbal tics. In Billie's case, she exhibits physical tics, not verbal, often in the form of eye rolls or head tilts. She said that she'd never planned to reveal this part of her life, but when someone made a compilation video of all the times Billie's symptoms appeared during interviews and posted it to YouTube, she decided to take matters into her own hands and set the record straight. 'I've just never wanted people to think of Tourette's every time they think of me,' she declared. How brave was that? Billie harnessed strength from a tough situation and completely owned it. If that isn't badass, then what is?

BE BAD, BE BOLD, BE BILLIE

- Try writing your own Billie-inspired lyrics whenever you feel sad, or simply write down some of Billie's words.
- Start a diary of your negative thoughts and feelings. Don't forget to make a note of what you were doing, watching or who you were talking to when you started to feel this way.
- Turn those negative 'BLUE' thoughts into true, positive ones!

How else can we learn self-acceptance in daily life? Registered nurse and mindfulness expert Jane Bozier says, 'Self-acceptance is about embracing all the different parts of yourself – the good and the bad. It's about not expecting life to be perfect (or yourself for that matter) all the time.' It doesn't always feel easy, but Bozier's six steps are a great place to start:

1 Practise self-compassion
2 Give yourself time and space
3 Accept and be proud of your strengths
4 Accept others
5 Accept your situation
6 Accept the 'here and now'.

Bozier writes that it helps not to be hard on yourself if you make a mistake or if things go wrong. Don't expect to get everything right all the time. No one can do that! It's easy to get into negative and unhelpful patterns of thought, but we can change the way we think.

BE BAD, BE BOLD, BE BILLIE

Answer the following questions:
- What are the characteristics you like best in yourself?
- How would a friend describe you?
- What one thing can you do better than anyone else you know?
- What might people be surprised to learn about you?

Knowing who your friends are is incredibly important when it comes to self-acceptance. We all need friends around us, but it's not the number we have, it's the quality of our friendships. You may have a huge amount of 'friends' on Facebook, or followers on Instagram, but how many of these are close, trusted friends? Think about who your true friends are and how you support each other. In our busy lives we know a lot of people, and that's OK if you know what to expect from them. In a *Sunday Times Magazine* interview, Billie said she used to have tons of friends: 'Friends on friends on friends on friends. I was popular as hell,' she declared, but admitted that, 18 months later, it was more like 'one or two' truly close friends.

In her book, *The Anxiety Solution*, Chloe Brotheridge suggests doing a 'relationship audit', so that you have good people around you to help boost your self-esteem rather than base your self-esteem on what others think. Brotheridge suggests you think about who you spend the most time with and how they make you feel. 'Do they build you up or drag you down? Maybe you're in a relationship with someone who doesn't support you, or you have a friend who's always competing against you or letting you down. It might be the moment to start being more assertive with these people – or let them go completely. Maybe it's about setting boundaries and letting them know what is and isn't OK.'

BE BAD, BE BOLD, BE BILLIE

- If you think a friend needs a little Billie-boost, ask how they are. If they reply, 'Fine', but you doubt it, ask again and let them know you're there for them.
- Have a hug – it can be more powerful than words.

'People underestimate the power of a young mind that is new to everything and experiencing for the first time. We're being ignored and it's so dumb. We know everything.'

GUIDE TO

SPEAKING UP

illie's no stranger to speaking her mind. We've seen how she took matters into her own hands and spoke up about her Tourette syndrome on Instagram, as well as how she has been vocal about her history with depression. We've seen that when she doesn't like something, she addresses it head-on and does something about it. She also talks honestly about it. Like when she deleted her Twitter account in 2019: 'I was in Europe, in one of the worst headspaces I've been in. That's when I realized, "You know what? Bye!" There are so many things I can't stop, but I can delete Twitter,' she told *ELLE*. 'I have too much love for myself – I don't need to see all these opinions. Shoo!'

Talk about doing what's right for yourself!

Billie has also defended herself when she needed to – taking control and putting messages out there herself rather than having a manager or label head do it for her. Take the small-scale backlash that came in 2019 with her song, 'wish you were gay'. In it, Billie is supposedly saying these words to a lover who has jilted her, but some people took that to be insensitive to the gay community. But Billie, who, as we know would never want to offend or insult her fans, addressed the situation head-on during an interview with PopBuzz: 'I tried so hard to not make it in any way offensive. The whole idea of the song is, it's kind of a joke. It's kind of like "I'm an ass and you don't love me... And I wish you didn't love me because you didn't love girls."'

There will, inevitably, always be times where you say the wrong thing, or someone doesn't like what you have said, even though your intention was never to cause harm or insult. We can all learn, however, to be a little more sensitive in the ways that we communicate. One of the best ways

to communicate better with others is to master the art of listening: 'Listen more than you talk.' This is what Sir Richard Branson – the business magnate who founded Virgin – has said. He's on to something! To communicate effectively, you must first listen to what others have to say. Then you can provide a thoughtful answer that shows you have taken those ideas into account and, hopefully, subsequently get your own point across better as well. It's always really important to see things from the other person's perspective. Often, there is no 'right' or 'wrong'; it's simply that you are coming from completely different views. And that's OK. Learning to listen to what others have to say (even if they don't show you the same respect in return) shows maturity and respect – and that goes a long way. You never know, you might be surprised to discover that you learn something from them as well.

BE BAD, BE BOLD, BE BILLIE

- Think back to the last time someone said something that annoyed or upset you.
- Can you think of two possible explanations as to why that person said what they did, other than saying it to be cruel to you? Could they have felt threatened? Is there something going on in their personal life perhaps that might make them lash out at you? Might they have said something thoughtless in passing without actually meaning to offend you?

> ⮑ If we try to have compassion for others it will make
> it easier to communicate with them in future.
> And even if it doesn't, learning compassion and
> listening instead of just talking will help you at
> some point in your life – trust us!

**❛While I feel your stares, your disapproval
or your sigh of relief, if I lived by them,
I'd never be able to move.❜**

Billie has also become an advocate for body image, speaking out about the shaming of women in the public eye. Shaming women everywhere, in fact. In early March 2020, she kicked off her world tour at the American Airlines Arena in Miami. Bursting onto the stage to rapturous applause, Billie delivered a powerful speech about body shaming: 'Would you like me to be smaller?' she asked her audience. 'Weaker? Softer? Taller? Would you like me to be quiet? Do my shoulders provoke you? Does my chest? Am I my stomach? My hips? The body I was born with – is it not what you wanted? If I wear what is comfortable, I am not a woman. If I shed the layers, I'm a slut. Though you've never seen my body, you still judge it and judge me for it. Why?'

Isn't it refreshing to hear a teenager talk so strongly, so passionately and concisely about something that affects every single one of us at some point or another? Yet again, Billie comes through and we love her for it. Go, Billie!

It's really important, however, to understand and appreciate that not everyone is as skilled at being vocal in this way. Billie, if you remember, has been a trained performer from a young age. Her parents were actors, something that no doubt has helped her! It's really no wonder that speaking out and speaking up come so naturally to Billie. Some people – and you probably know one or two of them – are born extroverts. This means that they feel comfortable in big or small groups and are probably quite sociable and outgoing. An introvert, on the other hand, will generally be quieter and more reserved, hanging back a bit and letting other louder, bolder and more confident types steal the limelight. From the outside, it might seem as though being an extrovert is more appealing: Don't we all wish from time to time that we were super-confident and outspoken, like Billie? Well, there's a lot to be said for being an introvert as well.

In her book, *SHY*, journalist and author Annie Ridout looks at some of the advantages of being one of the quieter types of people. 'Shy people tend to be more empathic, as they spend less time performing and more time in the audience, watching, observing,' says Ridout. 'Shy people talk less so spend more time with their thoughts, which makes them introspective. In fact, some of the world's great creatives – Thom Yorke, Elton John, Nicole Kidman – all claim to be shy. It's part of them, and so part of their success.'

But one of the obstacles of being shy is that it can be harder to perform. Whether you need to give a speech in class or do a presentation at work, most of us will, at some point during our professional careers, need to 'speak up' in some way. Here are Ridout's tips:

1. **Prepare.** 'Write notes and try them out over and over again, you'll feel more confident about delivering them on the day. Remember, you can almost always take notes with you, too.'

2. **See your success.** Before the event, 'imagine yourself up in front of an audience performing really confidently. We have a tendency to imagine how wrong it's going to go. Imagine it going right. Return to that same image, in your mind, as often as you can. Changing your thought process in advance of an event can change the outcome.'

3. **Remember that people have your back.** 'No one wants you to fail. If your voice wobbles, or you feel shaky, that's okay. Almost everyone feels a bit on edge performing in front of others, and everyone watching will want you to do well.'

BE BAD, BE BOLD, BE BILLIE

- Got a big presentation or speech coming up? Rehearse with your friend or relative and ask them for honest thoughts and feedback.
- Scan the audience as you are talking to them and make eye contact as you go. This will help focus you and keep them interested.
- Try to speak at a steady pace, rather than rushing through words. It's hard when you're nervous, but a few deep breaths should keep you on track. Remember, you can always stop and take a breath whenever you need to.
- Listen to a great Billie song that morning to give you a boost. Billie's music is always there for you!

'The world is ending and I honestly don't understand the law that says you have to be older to vote, because they're going to die soon and we'll have to deal with it. That doesn't make any sense to me. But to see young people taking part in peaceful protests and not obeying is beautiful.'

Another hot topic that Billie is wildly passionate about is climate change and sustainability. She has done so much in support of this cause. In September 2019 she posted a GIF to her Twitter account in which she swayed from side to side, dressed head-to-toe in an outfit that had 'TICK TOCK' emblazoned on it. We know Billie doesn't always post her own messages on Twitter but she would definitely have approved her team posting this one! And, no, she wasn't referring to the short-form video app, TikTok. The accompanying text in the tweet read: 'A note from Billie: "TICK TOCK! our time is running out. the climate crisis is very real. we need to speak up and demand that our leaders take action."' And she tagged climate change activist Greta Thunberg in the tweet as well. It was retweeted tens of thousands of times. No big deal.

'Extreme weather is wrecking millions of lives. We cannot let this happen on our watch.'

Also, in 2019, Billie recorded a video called *Climate Emergency* with the actor Woody Harrelson, in which they both looked solemnly into the camera lens and spoke about the harsh effects of climate change. 'Over one million species are

becoming extinct over mankind's actions. And time is running out,' said Billie. The video went on to accumulate millions of views across Twitter, Instagram, Facebook and YouTube.

Billie suggested one way to help the planet is by cutting out meat, dairy and animal products from your diet. She spent most of her life as a vegetarian before going fully vegan in 2014 – long before she was properly famous. In fact, veganism is one of the best ways you can help the planet, according to a study in *Science*. It argues that if everyone stopped eating meat and dairy – which takes up 83 per cent of global farmland – it would allow ecosystems around the world to recover from deforestation.

Now, this is just a suggestion Billie made and is absolutely not right for everyone. Some people need iron from meat or calcium from dairy if they have deficiencies (though it's worth a visit to your GP if you suspect this is the case as they might recommend that you take supplements; others simply can't afford to cut out these vital food groups). But at least Billie practises what she preaches. Even if you can't – or don't want to – go vegan, there are plenty of easy ways to truly help make a difference to the fight against climate change. And, if you're on the fence, why not try Meat Free Mondays as a starter?

BE BAD, BE BOLD, BE BILLIE

1. Turn off electrical appliances and switch off lights when you're not using them.
2. Buy energy-efficient light bulbs where possible.

3. **Turn down (or off!) the heating in winter.** Can you just wrap up instead?
4. **Grow your own food.** You don't necessarily need a garden; you can grow herbs in a pot from your windowsill or balcony.
5. **Recycle.** Google instructions on how to recycle in your local area and always check for the recyclable symbol on packaging. Bring your own bags to go shopping instead of buying plastic bags every time.
6. **Re-sell and donate.** By extending the life of any product, you help reduce dependence on disposable or cheaply made single-use products that end up in landfills. Sign up to eBay, Freecycle, craigslist or Gumtree, donate to charity shops and thrift stores or check Facebook pages for your local area for any appropriate listings. You and your friends could host parties where you all bring unwanted clothes and do a big swap, too.
7. **Don't drink bottled water.** Dependence on bottled water has added an enormous amount of plastic to the waste stream every year.
8. **Rely less on your car.** If you have one, only use it when you really need to and try to avoid short distances where you can walk (think of all the exercise you're getting this way too!). Maybe look into car-sharing with your friends or joining a service such as Zipcar, where you can rent a car just when you need one.

9. **Buy Fairtrade.** When purchasing products not generally made in the same country as you live, such as coffee, cocoa, sugar, tea, chocolate and fruit, look for the Fairtrade certification, which means it has been responsibly sourced.
10. **Sign up on social media.** Follow Twitter accounts @Greenpeace, @foe_us and @oceana for more tips and news.

It does not stop there. In September 2019, ahead of her Where Do We Go? World Tour, Billie told US talk show host Jimmy Fallon that she was trying to be 'as green as possible' by banning plastic straws, encouraging fans to bring their own water bottles and having multiple recycling bins placed in each venue. 'Because it's like, if something's recyclable, it doesn't matter unless there's a recycle bin,' she explained. Billie even said that every venue that she performs at on her world tour would feature a Billie Eilish Eco-Village, a place where fans could learn more about climate change and become more environmentally conscious.

Is there no end to this woman's skills and talent?

Apparently not! Another step in Billie's fight against climate change was to create and release a sustainable clothing range with high street giant H&M in January 2020. The pieces in the collection were typically 'Billie' and included printed T-shirts, bucket hats and oversized sweatshirts in her signature beige, black and neon green and featuring her official logo. Every item was made using materials that were sourced in a 'more sustainable way' assured the clothing brand. Billie wouldn't have had it any other way!

101

BE BAD, BE BOLD, BE BILLIE

THE SUSTAINABLE SOUND OF MUSIC

Where Billie leads, others follow. These bands are
also playing their part…

- The 1975 said that their next show in London will
 be powered by vegetable oil – and a tree will be
 planted for every ticket sold.
- Massive Attack are working with academics to
 map out an industry-wide eco-friendly alternative
 to touring.
- Coldplay stated in November 2019 that they would
 stop touring altogether until they can find a way
 to actively help the planet with shows instead of
 harming it.

Last, but not least, let's not forget how powerfully Billie
speaks up about all of these issues in her music. When she
released the music video for her track, 'all the good girls go to
hell', which featured powerful metaphors about how we are
destroying our planet, she wrote a personal note underneath
the video, urging people to join the global climate strikes
around 2019's Climate Action Summit: 'Our Earth is warming
up at an unprecedented rate, icecaps are melting, our oceans
are rising, our wildlife is being poisoned, and our forests are
burning,' she wrote underneath the film on YouTube.

In summary, Billie is the voice we all need. But you
knew that already.

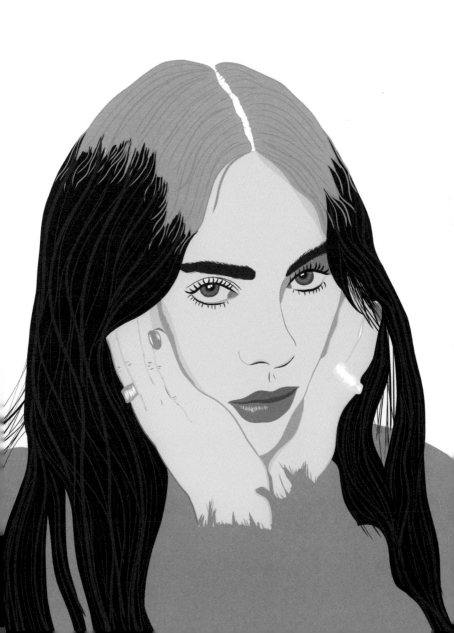

BE BAD, BE BOLD, BE BILLIE

🕱 Speak up if you want your voice heard. It's no use just tweeting your frustration about an issue that you care about, do some research into how you can be more involved. Maybe this is signing (or starting?) a petition? Maybe there are groups you can join or blogs you can write on. Billie would always encourage you to use your voice.

🕱 Don't get mad, get informed. The best first step to take if you're not happy about a national or global issue is to educate yourself about it. What newspapers, news apps, trusted websites or podcasts could better inform you of this topic? Have a look.

🕱 Talk to people you live with. Do you ever get frustrated that your relative or housemate isn't on the same page as you when it comes to sustainability or climate change? It's worth voicing your concerns but doing so in a calm and reasonable way. Who knows, maybe you'll actually get through to them and perhaps you'll learn something yourself.

'I'M TRYING TO SHOW EVERYBODY THAT I'M A GIRL, AND I'M FIVE FOOT FOUR, AND YOU CAN DO ANYTHING YOU WANT, NO MATTER YOUR GENDER. IT'S YOUR WORLD, TOO!'

'What makes a song last is real content from a mind that is thinking a little bit harder about certain things.'

BILLIE'S

TRACKS FOR

THE SOUL

Are you feeling crushed over a crush? Have you been let down by the world and need a bit of a boost? Turn to this, the ultimate playlist of Billie's best songs, to suit whatever mood you're in.

1. Feeling a bit insecure and done wrong by? Your song is:

'**WATCH**' Billie isn't going to let negative feelings, or negative people, win over her. Ever! This soaring anthem deserves to be played loud as you dance around your bedroom or stride down the street nodding your head to the beat. Billie is telling you that your inner strength will prevail no matter what particular challenges you face. It's OK to feel a bit insecure because we all do sometimes, even Billie.

2. When you're getting emosh thinking about a special someone:

'**EVERYTHING I WANTED**' 'Finneas is my brother and my best friend', so goes the text at the beginning of the music video. 'No matter the circumstance, we always have and will always be there for each other.' This song is for your someone and that someone could be a friend, a sibling or a partner, it doesn't matter. What Billie is saying in this song is how powerful and meaningful your feelings are about that person, especially when times get tough. Essentially, she's saying: 'I got you' and 'you

got this'. It's also a potent reminder that we might have all the fame and fortune in the world, but it doesn't really mean anything compared to those lasting, unbreakable bonds we share with others. Billie suggests none of her success would be that important to her anyway unless her big brother were there by her side.

3. When you're trying not to fall in love, but...

'**I LOVE YOU**' You've tried to fight that feeling, but it's no use, you're falling head over heels for that person you maybe know you shouldn't. Are they going to hurt you? Are you going to hurt them? Billie understands. But sometimes you just have to give in to that feeling. From the opening of the track – those gorgeous, gentle guitar chords – you know it's gonna be a teary number. Billie's whisper-voice is almost croaky, as if she's been crying. The whole thing is stunning!

4. When you need to feel empowered...

'**BURY A FRIEND**' You might not think this is the most empowering number if you were to break down the lyrics, or focus on the most provocative and famous lines. Make no mistake, they are pretty dark and macabre. But, if you listen carefully, this is actually a track about finding strength. And the pounding,

invigorating beats don't make you want to sit still, do they? This is so one for when you need some positive Billie motivation in your life!

5. When you're crushing on someone... hard!

'OCEAN EYES' It really is hard to believe that Finneas was only 18 when he wrote this song and Billie, at 14, managed to encapsulate its strong emotions so vividly. We've all been there, when you can't stop thinking about that one person and are totally and completely drawn to them. This dreamy ballad understands that their eyes may have been what snagged you, but it's the whole of them that you are so in love with.

6. When it's time for a badass morning anthem...

'BAD GUY' Unquestionably Billie's most iconic song, it's nothing short of a modern masterpiece. Not only is it skilfully produced by Billie and Finneas, but it's bold, cheeky and has incredibly catchy lyrics. It's also a great track for understanding when you're finally over that loser you were hung up on for a while. You've seen they're nothing but a fake and you couldn't care less!

7. When it's time to pick yourself up and shake it off...

'YOU SHOULD SEE ME IN A CROWN' You're gonna start this day on a high and kill it for the rest of the day! Someone at work giving you grief? Your ex had you crying all weekend because they've found someone new? Feeling broken in general? Jump out of bed and play this track at full volume then go out and own the night. Or the day, whichever works. Billie's got you!

8. When it's time to walk away...

'WHEN THE PARTY'S OVER' Like many of Billie's songs, her lyrics are poetic and the meanings behind them are not always immediately obvious. This is, of course, because Billie likes her art to be open to interpretation. What do you think of when you hear this track? We think it's about understanding when something has run its course – a job, a friendship, a romantic relationship or even, yes, a party! Sometimes you just need to know when to step away – and know that Billie has your back when you do.

9. When you're heartbroken...

'SHE'S BROKEN' This is such a an emotive song with unusually loud, strong vocals from Billie (unlike her trademark whispers). Billie sings about a girl who has been left distraught by a relationship, while the boy is

carrying on with his life. Sigh! But we all need that one song to play over and over when we're feeling blue and this is the one to help you through your heartache.

10. When you're feeling reckless...

'BELLYACHE' Although the lyrics here are pretty dark (typical Billie!), they are offset by the jolly guitar melody. It's not only a terrific one to sing along to, but it has the power to pick you up when you need it.

11. When all your friends are coupled up and the one person you fancy isn't interested...

'WISH YOU WERE GAY' OK, maybe you don't *really* wish that. But it sucks trying to get over someone you like, particularly when they've made it clear they're not that into you. If it's not hurting your heart, then it's hurting your pride. And Billie sure knows this. First of all, remember that this person wasn't right for you anyway – if they were, they'd be with you! Second, play this song as loud as you can and sing along. You'll feel great in no time!

12. When you're stepping out of your comfort zone and it's scary AF...

'LOVELY' Billie's strong, but she's also no stranger to fear. What do you think she's trying to tell you here?

Chances are it will be just the reassurance you need when facing your fears – and, let's face it, that will happen a lot in life. Ultimately, though, there is strength in fear and Billie wants you to know this.

13. When you're finally over that person...

'BORED' It's a fantastic feeling when you wake up and know that you're well and truly over that person. How dare they think they can still have a hold over you? Answer: They can't. This is an incredibly empowering song. Thanks, Billie!

14. When it's time to get the party started...

'MY STRANGE ADDICTION' A great banger to start the night off with. Defy anyone not to dance – or at least bounce in their chair – to this one. We love how versatile Billie's music is and this song is a prime example of that. Billie's a huge fan of the US version of *The Office* and has sampled dialogue from the TV comedy, which makes this track all the more weird and wonderful!

15. And for every other occasion possible...

'ALL THE GOOD GIRLS GO TO HELL' 'Are we watching a Billie Eilish video or a horror film?!' you might gasp at your first look of this video. Beady-eyed fans will

115

know it's a direct follow-on from the end of the video accompanying 'bury a friend', which ended with syringes being plunged into Billie's bare back. Now she's been reincarnated on Earth in black tar and wings. The song is about reinvention. There are lots of theories about the lyrics: some say it's about sexism, others about climate change. Whatever it's really about, it's a great track to sing along to at the top of your lungs.

Teenage dreams

Billie is so super-talented and cool and has achieved so much already in her career. Adults may think they have it all sussed out, but it's often the younger generation who have the power – and desire – to change the world for the better as they will be the ones who benefit most from any long-term changes. Here are some other badass, inspiring teenagers who, like Billie, are making a difference in the world today:

- **GRETA THUNBERG**
 Greta is more politically engaged than most politicians are! The environmental activist from Stockholm, Sweden, gained notoriety in August 2018 when, aged 15, she went on a school strike, using her time to protest outside Swedish parliament. She campaigns heavily for more action to be taken against climate change. To avoid flying, Thunberg sailed to North America, where she attended the 2019 UN Climate Action Summit and spoke in front of world leaders. She has been twice-nominated for the Nobel Peace Prize. On top of that, she does this all while managing her Asperger's syndrome, a condition which is a form of autism. She's an inspiration to millions.

'I DON'T KNOW HOW TO FUNCTION WITHOUT MUSIC. WHEN I'M NOT MAKING IT, I'M LISTENING TO IT. IT GIVES ME COURAGE AND TAKES CARE OF MY MIND.'

- **YARA SHAHIDI**
American actress Yara has been campaigning for years. She first gained prominence in the TV comedy, *Black-ish*, when she was just 14. A few years later, she landed her own spin-off TV show, *Grown-ish*. She uses the platform to speak to her millions of followers about feminism, social change and STEM (Science, Technology, Engineering and Mathematics). In 2018 she launched Eighteen x 18, an initiative to encourage young people to vote, and that same year, enrolled at Harvard to study sociology and African-American studies, recommended by none other than Michelle Obama!

- **AMIKA GEORGE**
North-London raised Amika campaigns to end period poverty in the UK. At the age of 17 and while still in secondary school, she started a petition, addressed to Westminster, pleading for more funds to be granted to British women who were unable to afford sanitary products and more support for schoolchildren. It gained over 200,000 signatures. In March 2019, the government announced that secondary schools in England would receive funding to provide sanitary products free of charge for poorer young people. Amika continues to campaign tirelessly for further reform.

BE BAD, BE BOLD, BE BILLIE

It truly doesn't matter how old or young you are, anyone can help make a difference and in these challenging times, it's more important than ever to make your voice heard if you want to. Write down three ways you would like to change the world. Don't be shy! No one has to see it. Here are some suggestions that might get you started...

- ♣ Start a petition. In the UK, if a petition gets at least 100,000 online signatures, it will be considered for debate in the House of Commons. Check out www.gov.uk for more info.
- ♣ Follow a blog or social media channel in your area of interest to keep up to speed on news – and how you might be able to get involved.
- ♣ Make a donation. If protests and speaking out aren't your thing, but you still want to make a difference, there are literally hundreds of charities you can support. You can donate anything – food, clothes, tampons – it doesn't have to be money if you can't afford it.

Billie would be so proud!

'I listen
to music all day
every day. I can't not
listen to music. It's kind
of scary how much I listen
to music, but it's what I
love, and it's all I care
about, so I'm good
with it.'

HOW **BLUE** ARE YOU?

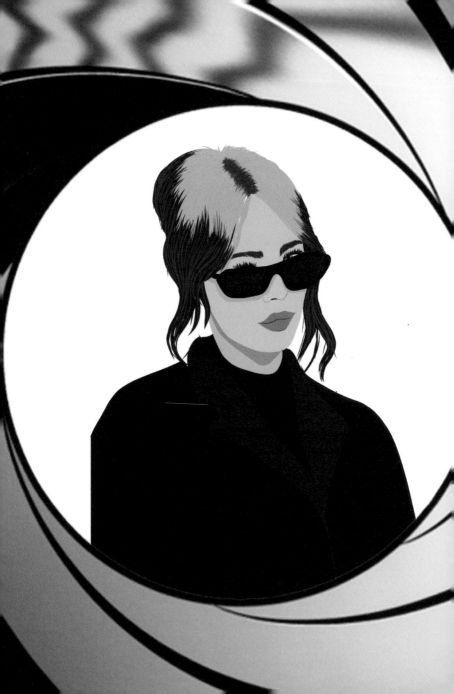

What would Billie do?

Pick a scenario from the list below and then use Billie's words of wisdom to try and solve that problem. If your particular issue isn't on this list, try writing it down in the space overleaf and then use Billie's advice to help you through.

Scenario

- You're feeling low about a conflict you had with a classmate or colleague. It's resolved now but you can't seem to shake that anxious feeling.

- You've got a big project coming up and are getting more and more anxious that it's no good or won't be ready on time...

- Your relationship has hit a rough patch. You are starting to feel like your partner is drifting away...

- You're in a rut. Nothing exciting seems to be happening for you...

- You can't really explain why, but you're feeling really sad today...

- You're about to start a new hobby, yay! But you're overcome with nerves...

- You've been invited to a party but you're worried you'll make a fool out of yourself if you go...

- It's been one of those days: You were late for work, got caught in a downpour, lost your bus ticket and now no one is returning your calls...

123

- Everyone on Instagram seems to be having the best time of their lives while you're sat at home eating chocolate...

- You've started a new job or course but are not quite sure that you fit in with the rest of the people there...

Or...

———————————————————

———————————————————

Billie's advice

- Be exactly who you are. Nothing is cooler than not caring what other people think.

- Take chances and take risks. It's fun to play a different character from time to time.

- You have to know that you are worth it, because you are. It doesn't matter who thinks what, it's your destiny and you're the one who controls it.

- Be patient. Things will get better, things will fade.

- What's wrong with being weird?! Being weird is being special. Billie thinks it's 'fun to be weird. It's your life. Do what you want'.

- There are always gonna be bad things but you can write them down and make a song out of it.

- Don't expect anything from the internet. It will disappoint you time and time again. You're better than that!

- Coming out of your shell is the most freeing feeling in the world.

- Don't ruin amazing things that could've been amazing just because you were sad.

- Please take care of yourself and be good to yourself and be nice to yourself.

'I'M REALIZING THE PLACE I'M IN RIGHT NOW IS KIND OF MY TIME. MY MOMENT. THESE ARE THE GOOD OLD DAYS.'

ow Billie are you *really*? Do you know your pop from your rock, your Chanel from your Burberry and your banjo from your ukulele? How old were you when you started penning your own lyrics? Are you even a Billie fan if you aren't passionate about a political cause? So grab your friends (or go solo!) and take these quizzes to test your Billie knowledge. And, don't worry, there's always room for improvement – simply stick on a few Billie tracks and you're on your way!

Describe your style in three words...
a. Glam, girly, gorge
b. Jeans, T-shirt, sneakers
c. Big, baggy, bold

Who would be your celebrity best friend?
a. Ooh, tough one! I kind of see myself as the fifth member of Little Mix, so probably one of them
b. No one of my generation. It would have to be a 90s rocker like Thom Yorke
c. It's a toss-up between Justin Bieber, Mel C and Leo DiCaprio. My phone is hella-full of famous numbers

And your real best friend?
a. A dear friend I met on social media. We DM-ed for weeks over our shared love of Jessica Simpson, started meeting up to do each other's make-up before nights out and now we're inseparable
b. My cat. She's always there for me
c. My brother, obvs

When was the last time you cried?
a. Last night, while watching *The Notebook*
b. Last night, while reading a nice message from my mother
c. Last night, while writing in my diary

What's your favourite instrument?
a. I've always thought I'd be great on the harp
b. I've dabbled in the ukulele
c. My voice. *Duh!*

What do you binge on Netflix?
a. *Gossip Girl*
b. *The Office*
c. *13 Reasons Why*

Who's your 90s pin-up?
a. The Spice Girls
b. Again, I'd have to go with a 90s rocker like Thom Yorke
c. Eminem all the way. He's so sick!

What was the last thing you posted on Instagram?
a. A Snapchat filtered selfie. I made my lips big and glossy, gave myself an Ariana-style ponytail and dog ears. Lol!
b. A sideways profile of me wearing big-ass sunglasses and looking moody
c. A sideways profile of me wearing big-ass sunglasses and looking moody, but with a neon filter

If you were on a movie set, what job would you have?

a. Lead actor, in front of all the action

b. I'd probably be behind the camera, doing something arty with the production team

c. Director. When I'm involved, I'm involved all the way and it's gonna be on my terms

What's your fave designer brand?

a. Victoria Beckham

b. Chanel

c. Burberry

What would you say to a friend who was going through a hard time?

a. Advice isn't really my thing. I'd probably just text them an inspirational quote

b. I'd write them a supportive song and sing it down the phone to them

c. I'd tell them not to care what anyone thinks of them, to delete negativity and that everything is going to be OK in the end. If that doesn't work, I'd make them sing and dance with me

Finally, how would you spend your dream Sunday?

a. Shopping

b. Sleeping

c. Binge-watching *The Office*

Mostly As

Hmm... You've certainly got some Billie in you, but you've still got some time to go before you've *fully* aced being Billie. That's OK, though! You're being true to yourself and that's cool with Billie. However, if you did want to be a *little* closer to Billie, go back and have a long, hard listen to *When We All Fall Asleep, Where Do We Go?* Maybe invest in a few chunky rings while you're at it.

Mostly Bs

You've sure got those long talons tapping in the right direction! To crank it up a notch, try making a new playlist with Billie's fave artists on there – Tyler, The Creator, Drake and Khalid – plus Billie herself, of course. Turn it up and dance like nobody's watching.

Mostly Cs

Wow! You're fire, bro! You are but a few Grammys away from being a full-on, certified member of the Eilish clan. You walk, talk and sound like Billie but most of all, you know what it truly means to be bad and bold and you're doing it in the most authentic way possible. So keep that swagger and spread the Billie joy wherever you go!

6 That's great, if I can make someone feel more free to do what they actually want to do instead of what they are expected to do. But for me, I never realized that I was expected to do anything. Nobody told me that shit, so I did what I wanted. 9

129

Which Billie Eilish song are you?

Answer the questions below, using the numbers in brackets as your score. Add up the total at the end.

What drink do you like best?
Canned coke (2)
Juice – any kind (1)
Black coffee. No sugar (3)

How old were you when you started writing music?
Under five (3)
Under 15 (2)
Under 25 (1)

Which app can't you live without?
Spotify (3)
Facebook (1)
WhatsApp (2)

Pick an artist...
Lana Del Rey (2)
Courtney Love (3)
Lizzo (1)

Pick a city...
Paris (1)
Los Angeles (2)
Tokyo (3)

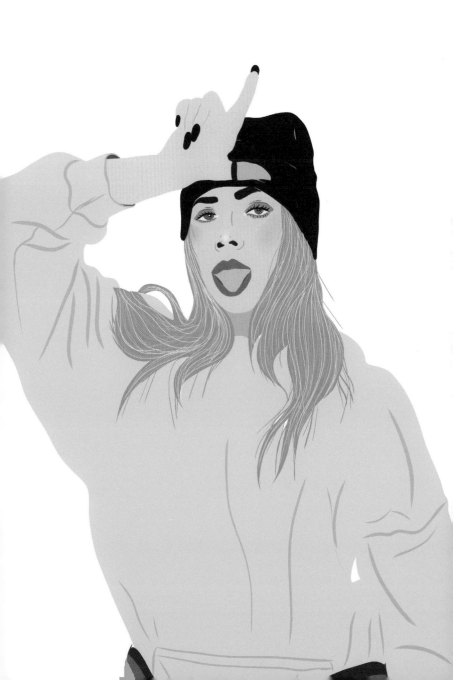

Which talk-show do you like the most?
Oprah (1)
James Corden's *The Late Late Show* (3)
The Ellen DeGeneres Show (2)

Which festival sums you up?
Coachella (1)
Reading or Leeds (3)
Latitude (2)

Which cause do you wish young people would get behind?
Anti-bullying (3)
Voting (2)
Climate Change (1)

How would you dye your hair?
Pink (1)
Green (2)
Black (3)

What's your score?
1–9 You're... 'ocean eyes'
Subtle, dreamy and sweet, that's you! You're basically Billie – but without the darkness!

10–18 You're... 'xanny'
You're deep, pensive and quiet. You're a listener too. People mistake that for being shy, but no, just like Billie, you're taking note of every little detail.

19–27 You're… 'bury a friend'
Woah, you're dark! You live on a diet of gothic literature and horror films. You monster! Billie would be so proud.

How well do you know Billie?

1. Which year was Billie born?
a. 2001
b. 2005
c. 2002
d. 2003

2. Which area of Los Angeles did Billie grow up in?
a. Hollywood Hills
b. Huntington Park
c. Highland Park
d. Highbury Park

3. What's the ninth song listed on the album, *When We All Fall Asleep, Where Do We Go?*
a. 'my strange addiction'
b. 'when the party's over'
c. 'ilomilo'
d. 'bury a friend'

4. Which song did Billie perform live at the 2020 BRIT Awards?
a. 'bad guy'
b. 'no time to die'
c. 'everything i wanted'
d. 'when the party's over'

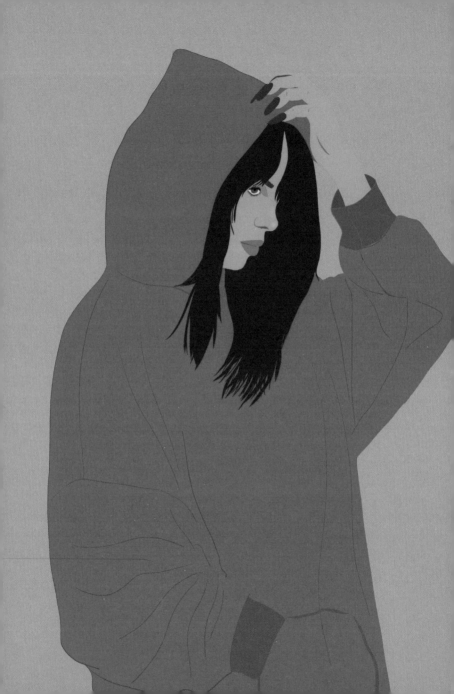

5. How many Grammys did Billie win in 2020?

a. Two
b. Six
c. Five
d. Four

6. What's the name of the horse that Billie used to ride?

a. Jackie Kennedy
b. Jackie O
c. Jack The Lad
d. O Jackie

7. What was the first song off *When We All Fall Asleep, Where Do We Go?* that Billie released as a single?

a. 'bad guy'
b. 'all the good girls go to hell'
c. 'xanny'
d. 'bury a friend'

8. On which date was Billie's brother Finneas O'Connell born?

a. 30 June
b. 4 July
c. 31 January
d. 30 July

9. Which designer did Billie wear on the Oscars red carpet in 2020?

a. Burberry

b. Chanel

c. Prada

d. Louis Vuitton

10. Which US chart position did 'wish you were gay' peak at?

a. 31

b. 14

c. 1

d. 29

11. After *The Office*, which TV show does Billie love best?

a. *Love Island*

b. *Friends*

c. *Sex and the City*

d. *The Walking Dead*

12. Billie once jokingly changed her Instagram handle to reflect a vegetable. Which one?

a. Carrot

b. Broccoli

c. Avocado

d. Cucumber

13. Billie plays two instruments – the ukulele and the...

a. Guitar
b. Banjo
c. Piano
d. Drums

when the party's over...

It's the name of a song from her album, but also brings this book nicely to a close (sorry to see you go, though!). We've covered a lot of ground within these pages and have come to know not only quite a bit about Billie but hopefully about ourselves too. It's astonishing to think just how far Billie has come in such a short space of time; the impact she has had all over the world; the way she has impressed the toughest of critics and speaks to an entire generation through her music. What makes Billie truly amazing is her ability to be true to herself and therefore authentic to her fans. Billie has more wisdom, maturity and experience than many people much older than she is. She doesn't take this for granted and appreciates every second.

A few months before she won her five (*five!*) Grammys, Billie was interviewed for *Entertainment Tonight* (FYI: the interviewer, Keltie Knight, had to tell Billie that she was the

youngest woman ever to be nominated in the Best Album category – Billie had no idea! Talk about down-to-earth). When she was asked if she had rehearsed her award acceptance speech already, Billie's horrified and baffled expression said it all! She followed up with: 'Do people really do that? I think it's so weird when people think they're going to be huge. I never in a million years thought this would happen. I'm only grateful for it. For real.'

Billie believes that, yes, it's great to dream big, to have aspirations and ambitions, but to remain grateful for everything you achieve along the way. What things, and which people, do you truly appreciate in your life? Do you tell them or show them regularly that you appreciate them? And do you take time every day to consider what you have?

A good way to practise this in everyday life is to write down three things that you are grateful for every night before bed, on a notepad or in your phone. It calms the mind and stops you getting worked up about things you don't have or haven't achieved yet. There are even plenty of smartphone apps dedicated to keeping a 'gratitude diary' and it's a really great habit to get into. Type 'gratitude journal' into your app store and loads will come up. Or try Presently: A Gratitude Journal, Gratitude: Personal Growth & Affirmations Journal, or Simple Gratitude Journal. You can be grateful for anything – your health, your friends, your home or that great feedback you got from a teacher or boss this week.

It also helps to keep healthy. Billie doesn't smoke or drink and she keeps active by, among other things, dancing around on stage for hours. Make sure that whatever is happening in your life, you are getting plenty of fresh air and exercise. Sleep is also really key for a healthy mind and body and a calm and focused outlook. Again, there are

plenty of apps you can download on your phone to help with meditation and sleep.

But what's also hugely important to remember is that it's OK to be lazy sometimes and it's OK to be unsure of what your hopes, dreams and ambitions are! Billie's message is to be kind to yourself. Your flaws (and we all have them!) are nothing to be ashamed of.

❝ Words are more powerful than some noises. Noises won't last long. Lyrics are so important. ❞

What we've also come to see – as if we didn't know it already! – is just how powerful and poetic Billie's words are. Let's look at one final quote here from an interview that Billie did in 2019, where she's talking about her fans, like you: 'I try to make everyone aware that I know they're suffering, and this is my art for you to hug and take as a comfort. I know some of my music, being as depressing as it is, may not sound like it's helping people, but talk to those girls who are sitting outside overnight to see me [to buy tickets to her shows or even just to catch a glimpse of Billie, or get a chance to meet her] and ask them if it's helping them.'

Billie knows that she can't always reach out to each and every one of us directly, but she wants to help. She wants us to listen to her words, her melodies and her messages to get us through whatever difficult thing we might be experiencing at school or college, at work or even at home. Billie understands.

Your party isn't over, it's just beginning!

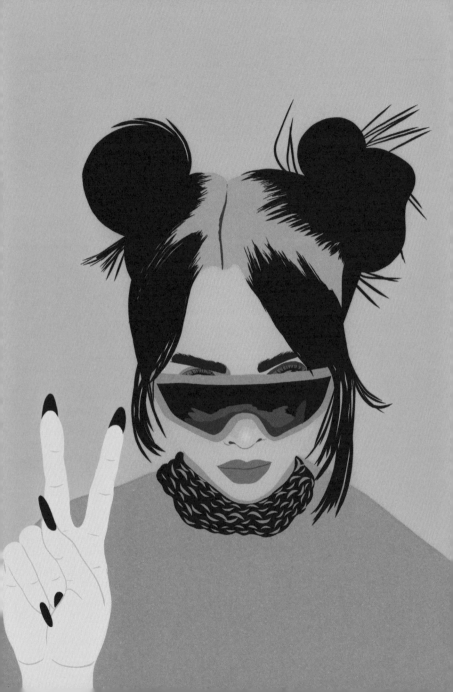

listen, before i go...

- Embrace your age – you won't have it for long! Billie isn't letting her youth hold her back!
- Billie got the best results when she followed her gut instinct and believed in herself. Believe in yourself, too.
- Billie has a hand in every piece of music she makes. What can you learn from her astute business acumen?
- Billie never hides who she is. Also, she doesn't need to bring other people down to make herself feel better. Be open, honest, kind and respectful, just like her.
- Billie knows the power of social media but she knows the dangers of it too. Keep a safe distance of harmful apps and trolls. They ain't worth it! Whats more, apps can keep you distracted and prevent you from getting on with tons of other things you could be doing. You have been warned...
- Billie knows who 'her people' are and she's loyal to them. It's better to have a couple of real, solid friendships than dozens of fake ones.
- Billie has faced criticism too, but just uses it as a tool and the motivation to stay strong, keep going and do better.

'I didn't think I would be happy again. And here I am – I've gotten to a point where I'm finally okay. It's not because I'm famous. It's not because I have a little more money. It's so many different things.'

RESOURCES

Introduction: An Ode to Billie

'Year End charts – Top Artists Female', Billboard

Copsey, Rob, 'The Official Top 40 biggest songs of 2018', Officialcharts.com, 3 Jan 2019

Billie Eilish, 'Bury A Friend', 30 Jan 2019

Eells, Josh, 'Billie Eilish and the Triumph of the Weird', RollingStone.com, 31 July 2019

McIntyre, Hugh, 'These Were The Most-Streamed Songs, Albums And Artists In The World On Spotify In 2019', Forbes.com, 3 Dec 2019

Jenkins, Craig, 'The Tide Has Rapidly Turned on Billie Eilish', Vulture.com, 6 Feb 2020

'Billie Eilish: Same Interview, The Third Year,' VanityFair.com, YouTube, 25 Nov 2019

Billie Makes It Happen

Aitkenhead, Decca, 'Teen Star Billie Eilish on therapy, her boyfriend and how fame has changed her', The Sunday Times, 29 June 2019

Haskell, Rob, 'How Billie Eilish is re-inventing pop stardom', Vogue.com, 3 Feb 2020

Graves, Shahlin, 'Interview 2017: Must know Billie Eilish', Coupe de Main Magazine, 23 Jan 2017

Weiss, Haley, 'Discovery: Billie Eilish', Interview Magazine, 27

Feb 2017

Rainey, Sarah, 'All together now: Singing is good for your body and soul', Telegraph, 10 July 2013

Barlow, Eve, 'Billie Eilish has already lived a hundred lives, and she's only 17', ELLE Magazine US, 5 Sept 2019

Marsh, Ariana, 'How Billie Eilish's Ocean Eyes turned her into an overnight sensation', Teen Vogue, 27 Feb 2017

Rider, Elizabeth, 'The Reason Vision Boards Work and How to Make One', HuffPost, 12 Jan 2015

Riopel, Leslie, 'The Importance, Benefits, and Value of Goal Setting', Positive Psychology, 18 March 2020

'Can relationships boost longevity and well-being?', Harvard Health Publishing, June 2017

'Health Advantages And Benefits Of Dancing And Singing', Vitarama

'Dance – Health Benefits', Victoria State Government

Billie Says Do You

Madonna, Sex, Hachette Book Group, Maverick, Callaway Arts & Entertainment, 21 Oct 1992

'Billie Eilish quotes', BrainyQuote

Aitkenhead, Decca, 'Teen Star Billie Eilish on therapy, her boyfriend and how fame has changed her', The Sunday Times, 29 June 2019

Ishak, Rave, '15 Ways To Feel More Comfortable In Your Own Skin Every Day', Bustle, 8 July 2016

Tartakovsky, Margarita, 'Practical Tools for Developing Your Self-Worth', psychcentral.com, 8 July 2018

Marsh, Ariana, 'How Billie Eilish's Ocean Eyes turned her into an overnight sensation', Teen Vogue, 27 Feb 2017

Rosenzweig, Mathias, 'V121: Billie Eilish by Pharrell', V Magazine, 19 Aug 2019

'Billie Eilish Speaks Her Truth in #MYCALVINS #CALVIN KLEIN', YouTube, 14 May 2019

Juma, Norbert, '50 Badass Billie Eilish Quotes To Channel Your Inner Rocker', everyday-power.com, 9 Dec 2019

Aswad, Jem, 'How Billie Eilish Took Control of Her Career Without Losing Her Soul', Variety.com

Billie Means Business

Smith, Thomas, 'Billie Eilish: the most talked-about teen on the planet', NME, 10 March 2019

Aitkenhead, Decca, 'Teen Star Billie Eilish on therapy, her boyfriend and how fame has changed her', The Sunday Times, 29 June 2019

Rosenzweig, Mathias, 'V121: Billie Eilish by Pharrell', V Magazine, 19 Aug 2019

Stassen, Murray, 'Behind Billie Eilish: Meet the Managers Guiding the Artist's Global Success', *Music Business Worldwide*, 2 May 2019

'Billie Eilish says her brother is "the only reason" she's alive', *Emirates 24/7*, 8 Dec 2019

Eells, Josh, 'Billie Eilish and the Triumph of the Weird', RollingStone.com, 31 July 2019

Mills, Corinne, 'How to deal with difficult people at work', *Guardian*, 10 May 2014

Barlow, Eve, 'Billie Eilish has already lived a hundred lives, and she's only 17', *ELLE Magazine US*, 5 Sept 2019

Billie Knows Her Strengths

Lumsden, Lottie, 'Billie Eilish says social media was "ruining my life" in a new interview', Cosmopolitan.co.uk, 18 Feb 2020

Barr, Sabrina, 'The Average Brit Checks Their Phone 10,000 Times a Year, Study Finds, Independent.co.uk, 1 Dec 2017

Robinson, Peter, 'Meet Billie Eilish: the dark-hearted teen sensation providing the soundtrack to 2019', *Evening Standard*, 27 Feb 2019

Miller, Caroline, 'Does Social Media Cause Depression?' Childmind.org

Barr, Sabrina, 'Six ways social media negatively affects your health', *Independent*, 10 Oct 2019

'34% of Generation Z Social Media Users Have Quit Social Media Entirely', *Business Wire*, 5 March 2018

Brotheridge, Chloe, *The Anxiety Solution: A Quieter Mind, a Calmer You*, Penguin, 23 Feb 2017

Edlin. Gabby, 'Bloody Good

Period', Instagram

'7 Teens using Social Media for Good Deeds', Smart Social, 16 Oct 2019

Smith, Thomas, 'Billie Eilish: the most talked-about teen on the planet', *NME*, 10 March 2019

Vanderhoof, Erin, 'Two Years Later, Billie Eilish Is Finally Happy', *VanityFair.com*, 25 Nov 2019

Fox, Laura, 'Billie Eilish leaves her biggest fan in TEARS by surprising her in emotional interview... after she praised the singer for helping her cope with life as a young carer', Dailymail.co.uk, 20 Feb 2020

Baltin, Steve, 'Dave Grohl Compares Billie Eilish to Nirvana in 1991', Variety.com, 12 Feb 2019

Hobbs, Thomas, 'Thom Yorke says he's a fan of Billie Eilish: "Nobody's telling her what to do"', nme.com, 7 July 2019

Nesvig, Kara, 'Justin Bieber Got Teary-Eyed Talking About Billie Eilish', TeenVogue.com, 15 Feb 2020

Evans, Mel, 'Billie Eilish reacts to Justin Bieber's tears as he gets emotional over wanting to protect her', Metro.co.uk, 16 Feb 2020

Coscarelli, Joe, 'Billie Eilish Is Not Your Typical 17-Year-Old Pop Star. Get Used to Her', nytimes.com, 28 March 2018

Petridis, Alex, '"I never wanted a normal life:" Billie Eilish, the Guardian artist of 2019', Guardian.co.uk, 19 Dec 2019

Billie Eilish Quotes

Haskell, Rob, 'How Billie Eilish is re-inventing pop stardom', Vogue.com, 3 Feb 2020

Goldsmith, Marshall and Helgesen, Sally, *How Women Rise: Break the 12 Habits Holding You Back from Your*

Next Raise, Promotion, Or Job, Penguin Random House, 2018

Strauss Cohen, Ilene, 'How to Let Go of the Need to Be Perfect', Psychologytoday. com, 12 Jan 2018

Gander, Kashmira, 'Why You Need to Stop Stressing About Being Perfect', Independent. co.uk, 3 Feb 2017

Billie Eilish: 'Nobody that knows me thinks I'm a dark person', CBSnews.com, 8 Dec 2019

'Billie Eilish: Same Interview, The Third Year', VanityFair.com, YouTube, 25 Nov 2019

US
National Alliance on Mental Illness: Nami.org
Mental Health America: MHAnational.org
The Trevor Project: Thetrevorproject.org

UK
Samaritans.org
Mind.org.uk
Papyrus-uk.org

Billie's Lessons in Self-Acceptance

Haskell, Rob, 'How Billie Eilish is re-inventing pop stardom', Vogue.com, 3 Feb 2020

'Mental health statistics: children and young people', mentalhealth.org.uk

Schraer, Rachel, 'Is young people's mental health getting worse?' BBC.co.uk, 11 Feb 2019

Trendell, Andrew, 'Billie Eilish on overcoming depression: "It's the most freeing feeling to be able to come out of that shell,"' nme.com, 9 Dec 2019

Eells, Josh, 'Billie Eilish and the Triumph of the Weird', RollingStone.com, 31 July 2019

Lynch, Julie; Prihodova, Lucia; J. Dunne, Padriac; Caroll, Aine;

Walsh, Cathal; McMahon, Geraldine; White, Barry, 'Mantra meditation for mental health in the general population: A systematic review', sciencedirect.com, Oct 2018

Morin, Amy, 'The Beginner's Guide to Changing Negative Thoughts', Psychologytoday. com, 9 May 2018

'What Works in Children's Mental Health', Practisewise.com

Krol, Charlotte, '"It doesn't make you weak to ask for help": Billie Eilish speaks powerfully about mental health for new campaign', NME.com, 23 May 2019

Bozier, Jane, 'How to accept myself for who I am? Try these six steps', bupa.co.uk, 9 Feb 2018

Aitkenhead, Decca, 'Teen Star Billie Eilish on therapy, her boyfriend and how fame has changed her', The Sunday Times, 29 June 2019.

Brotheridge, Chloe, The Anxiety Solution: A Quieter Mind, a Calmer You, Penguin, 2017

Barlow, Eve, 'Billie Eilish has already lived a hundred lives, and she's only 17', ELLE Magazine US, 5 Sept 2019

Billie's Guide to Speaking Up

Smith, Thomas, 'Billie Eilish: the most talked-about teen on the planet', NME, 10 March 2019

Prance, Sam, 'Billie Eilish responds to the "wish you were gay" backlash', PopBuzz, 7 March 2019

Barlow, Eve, 'Billie Eilish has already lived a hundred lives, and she's only 17', ELLE Magazine US, 5 Sept 2019

Patel, Deep, '14 Proven Ways to Improve Your Communication Skills', Entrepreneur Europe, 15 March 2019

Aviles, Gwen, 'Billie Eilish pushes back against body shaming with powerful speech', NBC News, 11 March 2019

Nicks, Sarah, 'WATCH: Billie Eilish Speaks Out Against Body-Shaming', Energy 106 All The Hits, 10 March 2020

ClimateEmergency, YouTube, 28 Sept 2019

Poore, J and Nemecek, T. 'Reducing food's environmental impacts through producers and consumers', Science, 1 June 2018

McCarthy, Joe, 'Going Vegan Is "Single Biggest Way' to Help Planet: Report"', Global Citizen, 1 June 2018

Hitchings-Hales, James, '6 Times Billie Eilish Spoke Out Against the Climate Crisis', Global Citizen, 19 Feb 2020

Spooner, Alicia M., 'Ten Ways to Live Sustainably', Dummies (no date)

Smith, Krista, 'Billie Eilish: The Young Upstarts with Co-Signs from Lorde and Halsey', Vanity Fair.com, 31 May 2018

Barr, Sabrina, 'Billie Eilish discusses upcoming eco-friendly world tour', Independent. co.uk, 29 Sept 2019

Barr, Sabrina, 'Billie Eilish releases sustainable clothing collection at H&M', Independent.co.uk, 3 Jan 2020

Clinton, Jane, 'The 1975 set to have their greenest-ever gig with hybrid-powered generators to reduce carbon footprint', inews.co.uk, 27 Jan 2020

Snapes, Laura, 'Coldplay pause touring until they can offer "environmentally beneficial" concerts', Guardian.co.uk, 21 Nov 2019

Eilish, Billie, 'All The Good Girls Go To Hell', 4 Sept 2019

Billie's Tracks for the Soul

'Billie Eilish quotes', BrainyQuote. com

How Billie Are You?

Ellis, Matthew, 'Billie Eilish quotes and sayings', Quotelicious,

Haskell, Rob, 'How Billie Eilish is re-inventing pop stardom', Vogue.com, 3 Feb 2020

'Billie Eilish Dishes on Turning 18, Winning a GRAMMY and What's Next', YouTube

Barlow, Eve, 'Billie Eilish has already lived a hundred lives, and she's only 17', ELLE Magazine US, 5 Sept 2019

'Billie Eilish quotes', BrainyQuote. com

Schiller, Rebecca, 'Billie Eilish Reveals the Lasting Piece of Advice She Got From Spice Girls' Mel C', Billboard.com, 18 Dec 2019

Andrews, Arden Fanning, '5 Times Billie Eilish Got Real About Mental Health', Vogue. com, 3 Feb 2020

Further Reading

Ariana Dunne: arianadunne.com

Brotheridge, Chloe. The Anxiety Solution: A Quieter Mind, A Calmer You, Penguin Random House, 2017

Goldsmith, Marshall and Helgesen, Sally. How Women Rise: Break the 12 Habits Holding You Back from Your Next Raise, Promotion, Or Job, Penguin Random House, 2018

Morin, Amy. 13 Things Mentally Strong Parents Don't Do: Raising Self-Assured Children and Training Their Brains for a Life of Happiness, Meaning, and Success, HarperCollins, 2017

Ridout, Annie. SHY, HarperCollins, 2021